Rowena Sunder,
Artist in New York

Rowena Sunder, Artist in New York

LINDA CAMPBELL FRANKLIN

McFarland & Company, Inc., Publishers
Jefferson, North Carolina

Library of Congress Cataloguing-in-Publication Data

Names: Franklin, Linda Campbell, author.
Title: Rowena Sunder, artist in New York / Linda Campbell Franklin.
Description: Jefferson, North Carolina : McFarland & Company, Inc., Publishers, 2018.
Identifiers: LCCN 2017057397 | ISBN 9781476674780 (softcover : acid free paper) ∞
Subjects: LCSH: Graphic novels.
Classification: LCC PN6727.F696 R69 2018 | DDC 741.5/973—dc23
LC record available at https://lccn.loc.gov/2017057397

British Library cataloguing data are available

ISBN (print) 978-1-4766-7478-0

Printed in the United States of America

*McFarland & Company, Inc., Publishers
Box 611, Jefferson, North Carolina 28640
www.mcfarlandpub.com*

Thank you everyone, especially Robbie.
If wishes were reality, Daddy would figure out a way
to read this aloud while Mummy hooked rugs,
and Mickey and I would laugh for hours.

This work is not a memoir, and contains exaggerated or irrelevant or counterfactual events. The characters are fictitious, and anyone resembling them will probably never be famous, regardless of flourish and artistic merit. Rowena would be pleased if any reader names a pet lizard or snake "Rowena Sunder." All psychological opinions expressed within are the author's, and were made during periods of intense concentration. Resemblance to actual events or locales or persons, living or dead, is entirely artistic although the cats and the ocelot and the talking fish were real. The red dress was real, though ruined in a rainstorm after attending Antonioni's *The Red Desert*. The coffee shop and the Museum of Invention are figments but the Electric Circus was real, as was Chumley's and the Household Refuse Dump. The 94th Street apartment building is really where the author lived, but the pink chair is fictitious. Enquiring minds will find worthy tidbits sprinkled throughout, and the quotations on every page are Rowena's way of sharing thoughts by authors worthy of attention. For safety's sake, do not attempt to fly on an ampersand or encourage anyone else to do it. Googling "Rowena Sunder" may result in further adventures.

"What I mean to say is, it's not as if it's the whole picture. Lots of other stuff happened. No end of things."
—Alan Bennett, *The Lady in the Van*, 1999

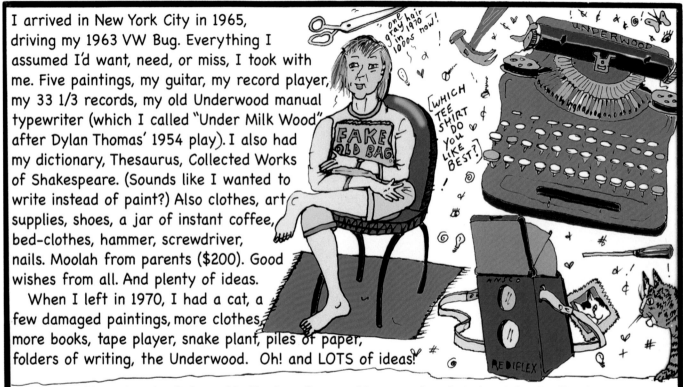

I arrived in New York City in 1965, driving my 1963 VW Bug. Everything I assumed I'd want, need, or miss, I took with me. Five paintings, my guitar, my record player, my 33 1/3 records, my old Underwood manual typewriter (which I called "Under Milk Wood" after Dylan Thomas' 1954 play). I also had my dictionary, Thesaurus, Collected Works of Shakespeare. (Sounds like I wanted to write instead of paint?) Also clothes, art supplies, shoes, a jar of instant coffee, bed-clothes, hammer, screwdriver, nails. Moolah from parents ($200). Good wishes from all. And plenty of ideas.

When I left in 1970, I had a cat, a few damaged paintings, more clothes, more books, tape player, snake plant, piles of paper, folders of writing, the Underwood. Oh! and LOTS of ideas!

"Titbits and topsyturvies, bobs and buttontops, bags and bones, ash and rind and dandruff and nailparings, saliva and snowflakes and moulted feathers of dreams. . ."

~Dylan Thomas, *Under Milk Wood* (A Play for Voices), 1954

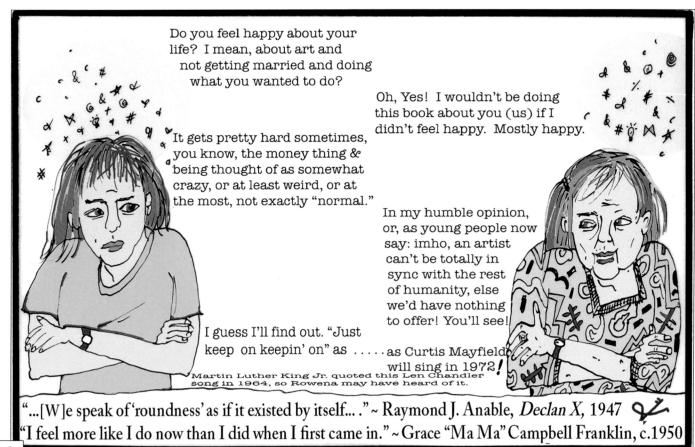

Do you feel happy about your life? I mean, about art and not getting married and doing what you wanted to do?

It gets pretty hard sometimes, you know, the money thing & being thought of as somewhat crazy, or at least weird, or at the most, not exactly "normal."

Oh, Yes! I wouldn't be doing this book about you (us) if I didn't feel happy. Mostly happy.

In my humble opinion, or, as young people now say: imho, an artist can't be totally in sync with the rest of humanity, else we'd have nothing to offer! You'll see!

I guess I'll find out. "Just keep on keepin' on" as as Curtis Mayfield will sing in 1972!

Martin Luther King Jr. quoted this Len Chandler song in 1964, so Rowena may have heard of it.

"...[W]e speak of 'roundness' as if it existed by itself... ." ~ Raymond J. Anable, *Declan X,* 1947

"I feel more like I do now than I did when I first came in." ~ Grace "Ma Ma" Campbell Franklin, c.1950

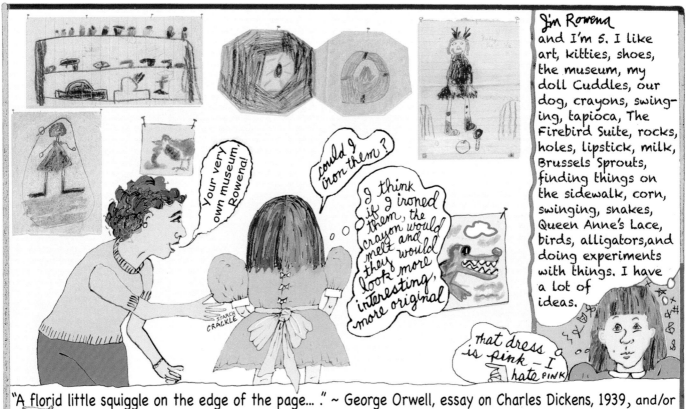

"A florid little squiggle on the edge of the page... ." ~ George Orwell, essay on Charles Dickens, 1939, and/or "Every child is an artist. The problem is how to remain an artist once he grows up." ~ Pablo Picasso (1881–1973)

"You can't use up creativity. The more you use, the more you have." ~ Maya Angelou, 1989 [*Conversations with Maya Angelou,* by Jeffrey M. Elliot] & "I never knew what I was doing until I was done." ~ Man Ray

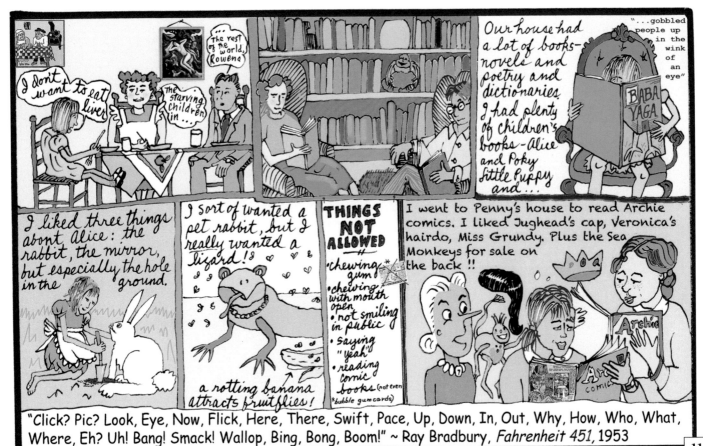

"Click? Pic? Look, Eye, Now, Flick, Here, There, Swift, Pace, Up, Down, In, Out, Why, How, Who, What, Where, Eh? Uh! Bang! Smack! Wallop, Bing, Bong, Boom!" ~ Ray Bradbury, *Fahrenheit 451,* 1953

11

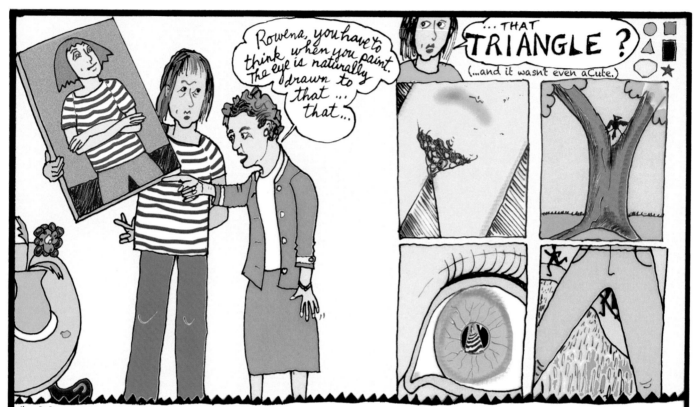

"... [C]ramp them into patterns or forms which were originally devised to order other and quite different elements... "
~ John A. Kouwenhoven, *The Beer Can by the Highway. Essays on What's "American" about America,* 1967

"Composition...alters itself according to the surface to be covered... ." Henri Matisse, 1908 *and* "The entire arrangement of my picture is expressive; the place occupied by the figures, the empty spaces around them, the proportions, everything has its share." ~ Henri Matisse (1869–1954)

13

When I was 14 or 15 I used to write poems, in bed, before going to sleep. When I learned to type, I would type my poems the next day. I can't find the notebook so here's the typed copy of my Fisherman poem. I guess I was already thinking about going away "somewhere"!!

There once was a fisherman
who had never been Somewhere
else besides where he'd always
been. He in his big rowboat went
every day as far as the island
everyone could see from shore.
Everyone wondered if he was afraid.
He caught all the same fish and
he saw the same things and his
horizon was only two miles
away. How many fish could a lone
fisherman eat? Perch omelets,
and sandwiches of sardines,
roasted bass with beans.

1.

A morning when the sky was not red
so no Sailor's Warning Dream, the
fisherman thought, "I'll row farther ...
or further ... than here!" He made a fish
lunch, some cans of water, he put on
clean socks and rowed his rowboat
past his usual horizon and cast
the line. Guess what he caught?
A mermaid with lavender eyes.
What a Somewhere surprise!
Of course he didn't eat her but he
did give her half his sandwich and
they talked for a while and he drew
a picture of her with his finger dipped
in water. The mermaid and drawing
both disappeared to Nowhere.

2.

The Fisherman
by
Rowena Sunder
October 12, 1956

"And after that life went on as before." ~ Anton Chekhov, *The Two Volodyas*, 1893
"Five little puppies dug a hole under the fence and went for a walk in the wide, wide world."
~ Janette Sebring Lowrey, *The Poky Little Puppy*, 1942 (Gustaf Tenggren, illustrator)

14

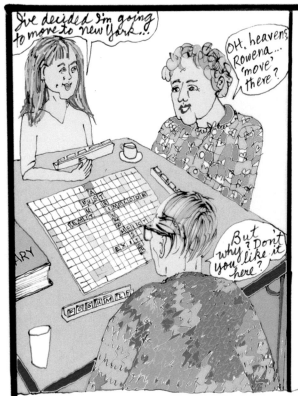

YOU CAN GO HOME AGAIN, HUH?

(At the Sunders' card table during a Scrabble™ game, late Summer, 1965)

Rowena: *(bravely)* I need, I mean I **WANT**, to go someplace else and try something on my own. I mean, I love you, but I'm 22 years old and, um, after all, why go to university if you don't, you know, try to see the, uh, universe?

Mrs. Sunder: *(puzzled)* But New York City? Moving there is different from a family trip there, seeing a few shows, shopping at S. Klein's, riding the subway. . . then . . .

Mr. Sunder: *(heartily)* . . . coming back **HOME**!!! Opportunities abound here! I know lots of people who can fit you right into . . .

Mrs. Sunder: *(trillingly)* "Home is where the heart is. . . Row row row your boat, um, gently dow-ow-own home. . . merrily, merrily, merrily, merrily, life is but a dream!

Rowena: *You* know lots of people, Dad. They're **ALL DOWNTOWN IN OFFICES**! I don't want to wear a dress, or a blouse and skirt and stockings everyday to ride downtown with you to some, some stupid job! I don't want to be a secretary!

Mrs. Sunder: *(slyly)* But, honey, do you really think being an artist is remunerative?

Rowena: Oh, Mom. What a question. Gee whiz! Is being a housewife remunerative?

Mrs. Sunder: *(shocked)* That was very rude, Rowena. Your father and I are very . . .

Rowena: Sorry, um, each to his own. But art isn't about money money **MONEY**.

Mr. Sunder: *(wisely and authoritatively)* Money makes the world go 'round, Rowena. Don't disparage money. It's cold hard cash that paid for your "universe" of art school.

Rowena: *(muttering)* "Sixteen tons and whadya get? Another day older and deeper in debt." My friends all think I should go to New York. And it's not like I don't have *some* skills of use in the marketplace. New York has millions of jobs, all I need is one.

Mr. Sunder: *(soothingly but managerially)* We don't need to decide this tonight. Let's get back to our game. I believe it's your turn, Rowena. There's a good opportunity on the board, I see. Don't you have something that will go down from **E X I T** ???

Mrs. Sunder: *(makes clucking sounds)* Oh my, yes! *Your* turn, Rowena!

"The fence was covered with birds. Their problem, in many ways a paradigm of our own, was 'to fly'." ~ Donald Barthelme, *Snow White* , 1967

15

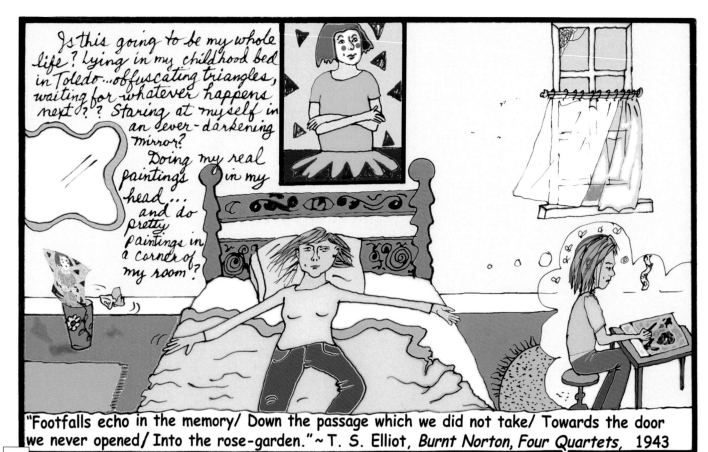

Is this going to be my whole life? Lying in my childhood bed in Toledo...obfuscating triangles, waiting for whatever happens next?? Staring at myself in an ever-darkening mirror?

Doing my real paintings in my head... and do pretty paintings in a corner of my room?

"Footfalls echo in the memory/ Down the passage which we did not take/ Towards the door we never opened/ Into the rose-garden." ~ T. S. Elliot, *Burnt Norton, Four Quartets*, 1943

16

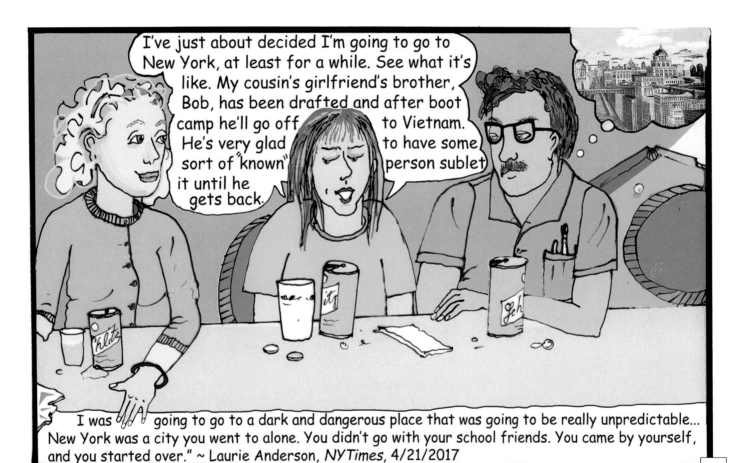

"I was going to go to a dark and dangerous place that was going to be really unpredictable... New York was a city you went to alone. You didn't go with your school friends. You came by yourself, and you started over." ~ Laurie Anderson, *NYTimes*, 4/21/2017

17

It's not "sudden" at all, Dad. In fact, well, it's not as if I just woke up one day and thought, "I think I'll run away from home and become an artist." I am an artist. It's the only thing I know how to do besides write awful poems and cut the grass and make banana prune cream pie. That's it! Wow! I've got a cheap place to live, I have a car, I even have a job! New York isn't any more dangerous than Toledo. I do know how to be more careful now.

Besides -- I'll write home, and there's that new invention the TELEPHONE! You know, "Brrrrringg Brrrrriiinnnnnggg!"

SIGH

"It's little I care what path I take, / And where it leads it's little I care; But out of this house, lest my heart break,/ I must go, and off somewhere." ~ Edna St. Vincent Millay, *Departure,* 1919

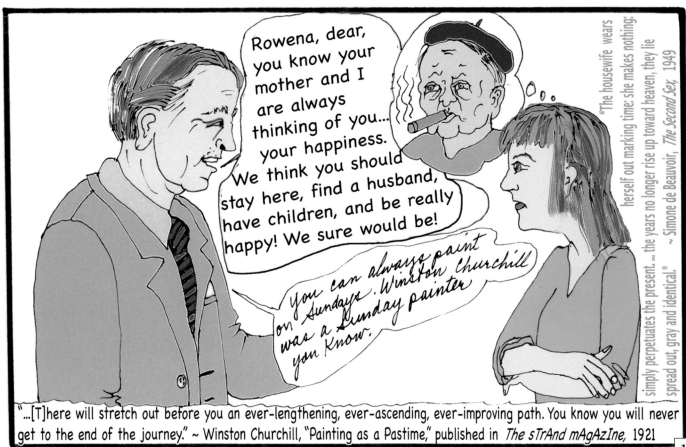

"...[T]here will stretch out before you an ever-lengthening, ever-ascending, ever-improving path. You know you will never get to the end of the journey." ~ Winston Churchill, "Painting as a Pastime," published in *The sTrAnd mAgAzIne,* 1921

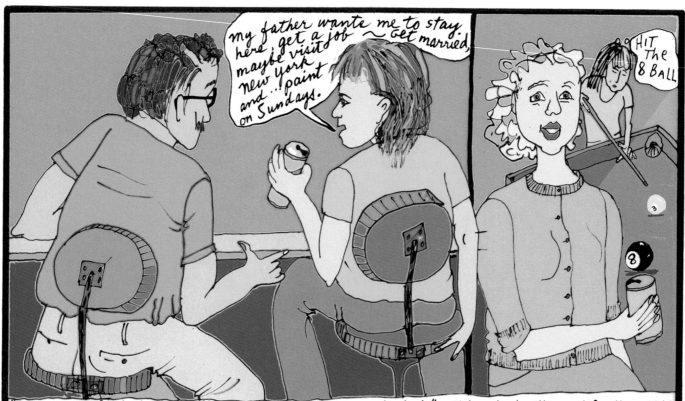

"Because your front wheels do different things than your rear wheels do." ~ Uniroyal advertisement for tires, 1969

"Batteries...they just sit there and don't do anything." ~ Sears DieHard Batteries advertisement, 1969

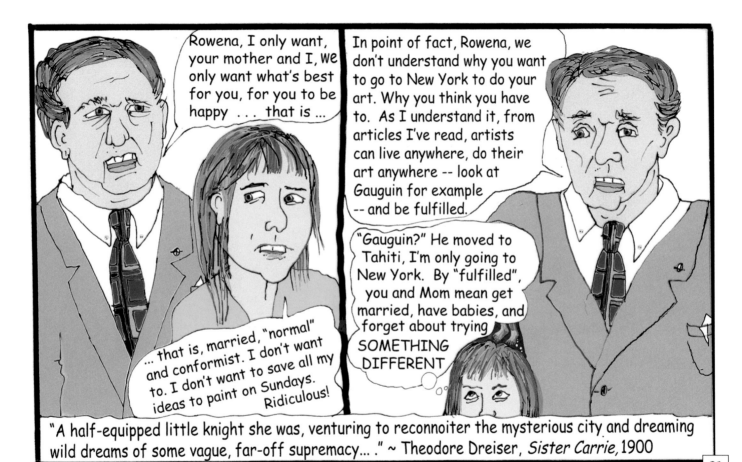

"A half-equipped little knight she was, venturing to reconnoiter the mysterious city and dreaming wild dreams of some vague, far-off supremacy... ." ~ Theodore Dreiser, *Sister Carrie,* 1900

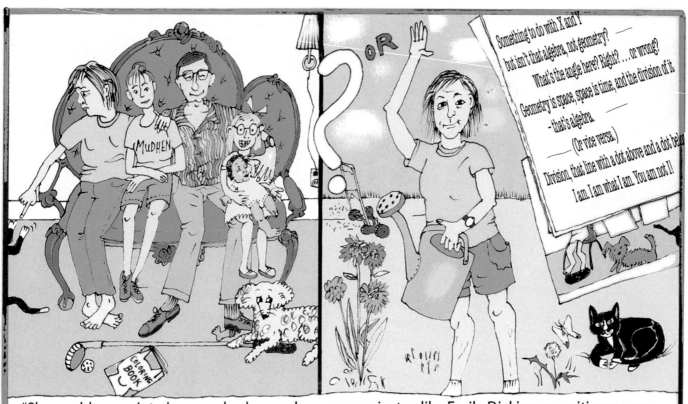

"She could move into her own bedroom...become a spinster, like Emily Dickinson, writing poems full of dashes and brilliance," ~ Jeffrey Eugenides, *The Marriage Plot,* 2011

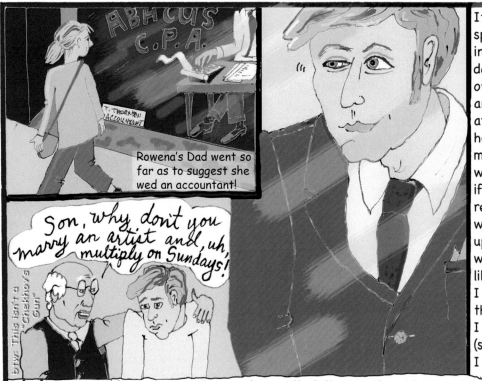

It's not like I had anything specifically against accountants, in fact, there was one I'd seen downtown through the window of an office. He warranted another look. He added up very attractively. BUT for one thing: he was seated at an adding machine. Conversely, he was wearing red socks. But I doubted if anything else about him was rebellious. I mean, who would want to sit in an office adding up numbers all day? In the window? Now, if he looked like James Dean (he did slightly) I might . . . well, no. Not even though he winked at me when I walked by the third time (stumble stumble Sasquatch) I want red high heeled sneakers.

"...[W]hen you add one to one, I am not sure that the one to which one is added has become two, or that the one added and the one to which it is added become, by the addition two." ~ Plato, *Phaedo*, 360 BCE. (Translated by F. J. Church, 1956) & "But nothing came of anything. I would go home instead, and write poems." ~Erica Jong, *Fear of Flying*, 1973

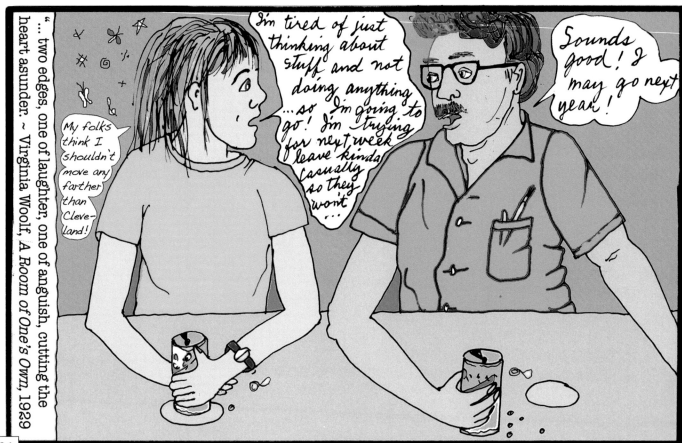

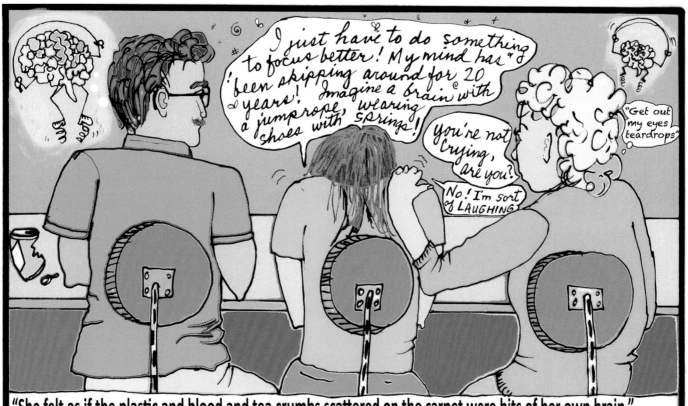

"She felt as if the plastic and blood and tea crumbs scattered on the carpet were bits of her own brain."
~ Jay Cantor, *Krazy Kat. A Novel in Five Panels*, 1988. and/or "Thut, thit, thot didn't bother her. (*Did* it?)." op. cit.

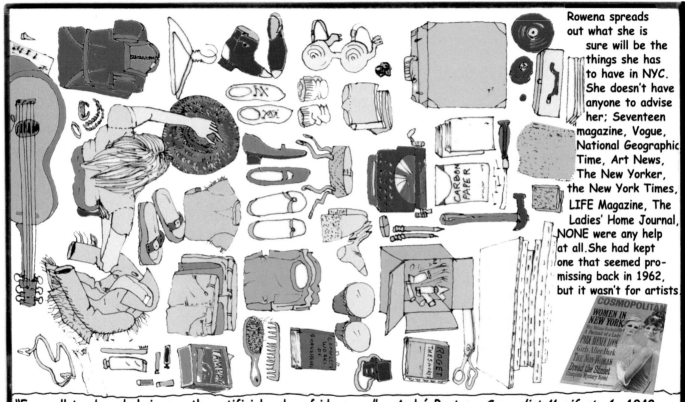

Rowena spreads out what she is sure will be the things she has to have in NYC. She doesn't have anyone to advise her; Seventeen magazine, Vogue, National Geographic, Time, Art News, The New Yorker, the New York Times, LIFE Magazine, The Ladies' Home Journal, NONE were any help at all. She had kept one that seemed promissing back in 1962, but it wasn't for artists.

"Farewell to absurd choices ...the artificial order of ideas. ..." ~ André Breton, *Surrealist Manifesto 1,* 1942
"When a girl lives alone it's wonderful at first: a room of one's own, but it can be lonely, too...so" ~ Magazine ad, 1951

There was a goodbye party for me, and everyone said they'd visit sometime while I was there...not all at once. It was a fun party -- beer, music and a few candles. I wore my lucky orange hat and friends told me I had to take it with me. I'm going to miss all my friends. The redhead is Mike, the blonde is Amie.

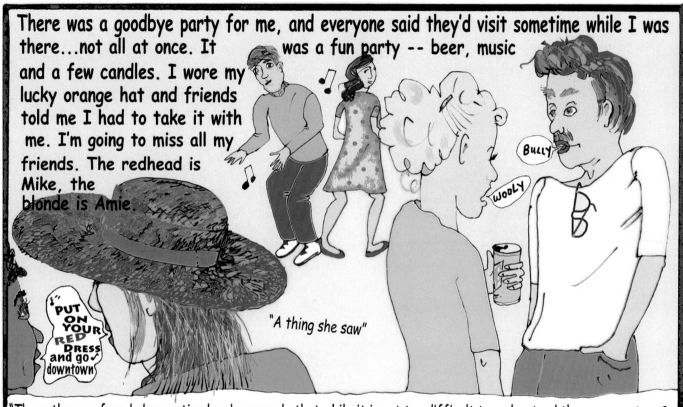

"A thing she saw"

"The rather profound observation has been made that while it is not too difficult to understand the movements of one eye, unfortunately there are two." ~ Richard G. Scobbee, *The Oculorotary Muscles*, 1947

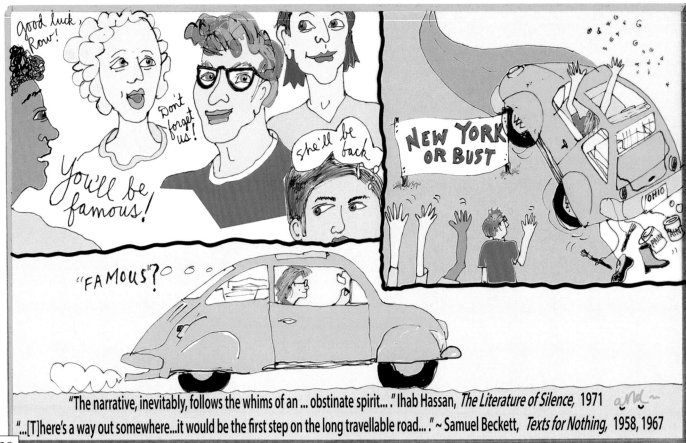

"The narrative, inevitably, follows the whims of an ... obstinate spirit... ." Ihab Hassan, *The Literature of Silence*, 1971

"...[T]here's a way out somewhere...it would be the first step on the long travellable road... ." ~ Samuel Beckett, *Texts for Nothing*, 1958, 1967

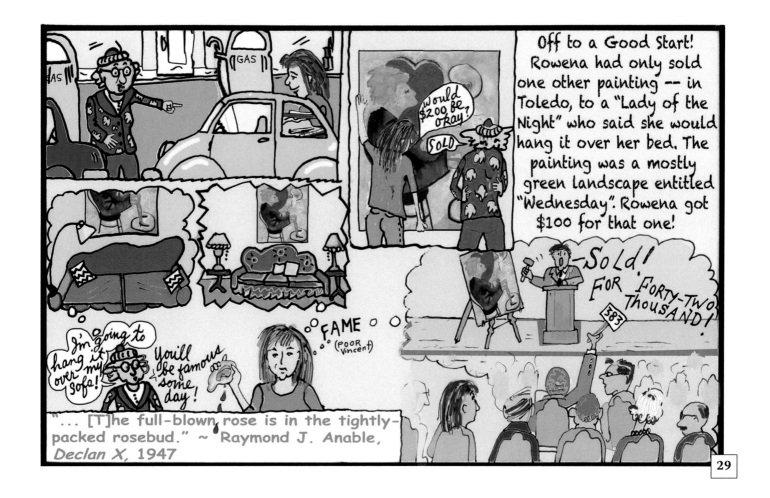

Off to a Good Start! Rowena had only sold one other painting -- in Toledo, to a "Lady of the Night" who said she would hang it over her bed. The painting was a mostly green landscape entitled "Wednesday". Rowena got $100 for that one!

"... [T]he full-blown rose is in the tightly-packed rosebud." ~ Raymond J. Anable, *Declan X*, 1947

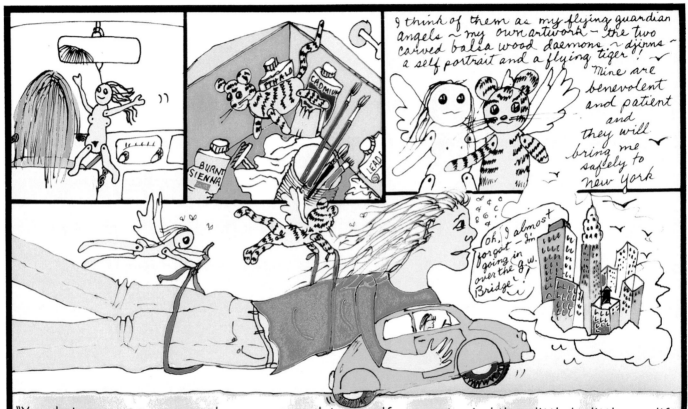

I think of them as my flying guardian angels ~ my own artwork ~ the two carved balsa wood daemons ~ djinns ~ a self portrait and a flying tiger!

Mine are benevolent and patient and they will bring me safely to New York

Oh, I almost forgot ~ I'm going in over the G.W. Bridge!

"You shut your eyes; you spread your arms; you let yourself evaporate. And then, little by little, you lift yourself off the ground. Like so." ~ Paul Auster, *Mr. Vertigo*, 1994

It is September 12, 1965 in the middle of rush hour. Engineer Ottmar Amman, who designed the George Washington Bridge will die in 10 days & a small plane will crash on the GW the same day.

The sun will soon set, but right now the light is glaring. Rowena's feet are busy...a stick shift in this traffic is pretty hard!

The Pedal Polka Tapdance

"A person, like music, is an aesthetic reality; for every moment of his life, he is at once rest and motion, sameness and change." ~ Eli Siegel, *Self and World: An Explanation of Aesthetic Realism*, [written 1941-43]

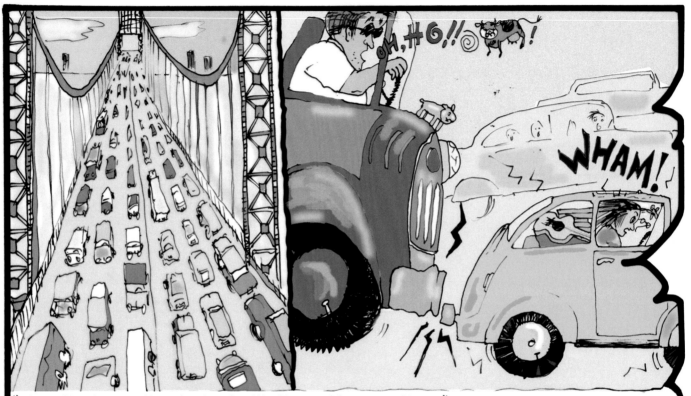

"Then the bowsprit got mixed with the rudder sometimes." ~Lewis Carroll (Charles Lutwidge Dodgson), *"The Bellman's Speech" in The Hunting of the Snark*, 1876

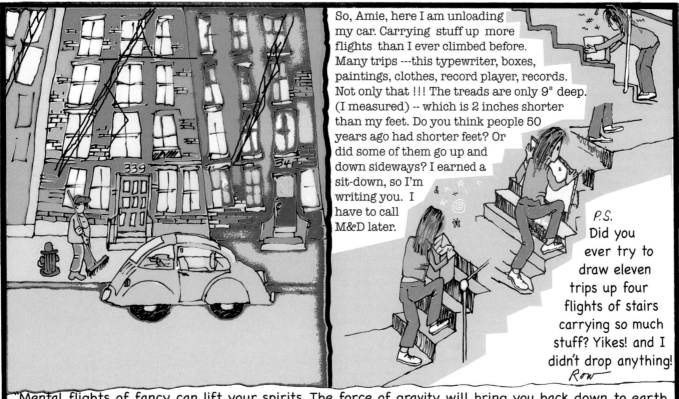

So, Amie, here I am unloading my car. Carrying stuff up more flights than I ever climbed before. Many trips ---this typewriter, boxes, paintings, clothes, record player, records. Not only that !!! The treads are only 9" deep. (I measured) -- which is 2 inches shorter than my feet. Do you think people 50 years ago had shorter feet? Or did some of them go up and down sideways? I earned a sit-down, so I'm writing you. I have to call M&D later.

P.S. Did you ever try to draw eleven trips up four flights of stairs carrying so much stuff? Yikes! and I didn't drop anything!
Ron

"Mental flights of fancy can lift your spirits. The force of gravity will bring you back down to earth quickly, but in the meantime, jot down your ideas and stash them away for future use." ~ Aquarius *astrological forecast*, 2016 and "So too with artists. Only more so." ~ Erica Jong, *Fear of Flying*, 1973

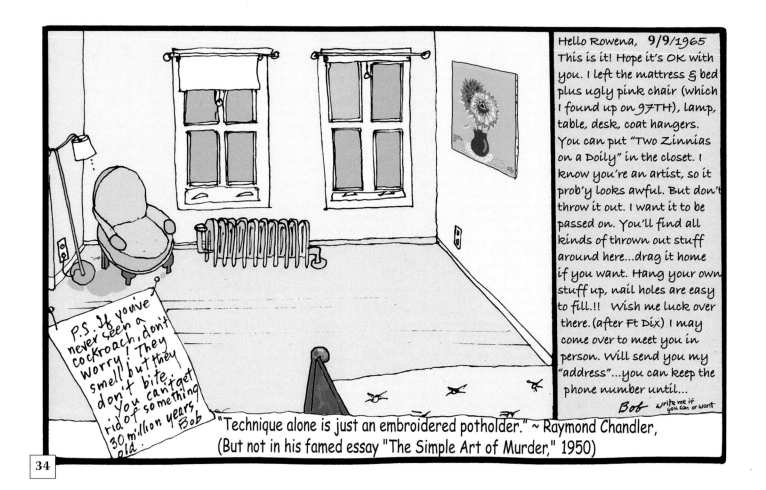

Hello Rowena, 9/9/1965
This is it! Hope it's OK with you. I left the mattress & bed plus ugly pink chair (which I found up on 97TH), lamp, table, desk, coat hangers. You can put "Two Zinnias on a Doily" in the closet. I know you're an artist, so it prob'y looks awful. But don't throw it out. I want it to be passed on. You'll find all kinds of thrown out stuff around here...drag it home if you want. Hang your own stuff up, nail holes are easy to fill.!! Wish me luck over there. (after Ft Dix) I may come over to meet you in person. Will send you my "address"...you can keep the phone number until...

Bob Write me if you can or want

P.S. If you've never seen a cockroach, don't worry! They smell but they don't bite. You can't get rid of something 30 million years old. Bob

"Technique alone is just an embroidered potholder." ~ Raymond Chandler, (But not in his famed essay "The Simple Art of Murder," 1950)

34

ROWEN A'SUNDER MANIFESTO
September 1965

ART is anything you pay attention to and then do something to by adding yourself or your mind to it. This doesn't include killing something. Art can be found as often outside a museum or art gallery as inside. Failed art is as much art as good art.

1) Any idea for an art piece isn't "art" until I do it! For example, this cat outside my window won't be art himself, but when I make a picture or sculpture of him he will be the subject of an "art" piece.

2) I won't let others tell me what are proper subjects. My painting teacher said a clothesline is not a fit subject for a painting. Oh no?

3) I won't pay attention when someone says "That isn't art" because they don't like the subject, color, technique, or lack of critical recognition or attention. "Art is never beautiful. . . for all." -- Dada Founding Manifesto, 1909

4) I will strive to create what I personally like, but not by planning ahead. Art can be made of accidents and found objects. I'll do the best I can with composition –proportion of forms and placement on the surface or in space; color; subject matter, until I think it's done.

5) I'll title my work because I like titles. I think people who look at a painting with a title will come up with as many of their own ideas about the meaning or the subject as do people who look at an "Untitled" painting. Is "Untitled #8" about nothing? Or eight?

6) I'll write down my ideas, so that in the future I can use them. I'll try hard to focus and proceed. *Rowena Sunder*

New York City

"I...conclude that after all everyone dances to his own personal boomboom, and that the writer is entitled to his boomboom."~ Tristan Tzara, *"Dada Manifesto 1918"* & The new painter creates a world... ." op. cit.

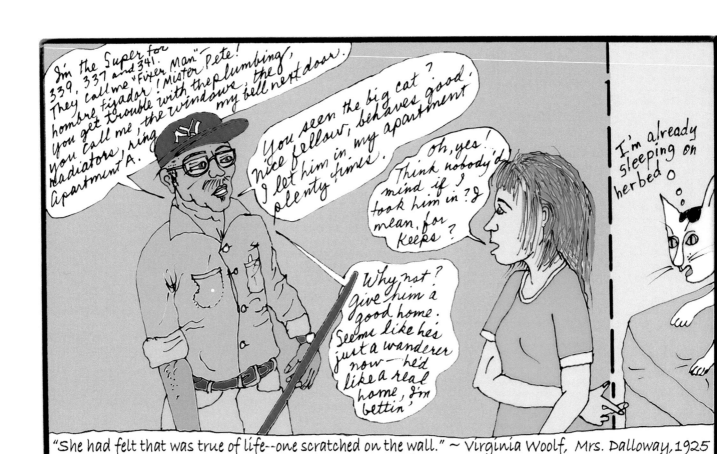

"She had felt that was true of life--one scratched on the wall." ~ Virginia Woolf, Mrs. Dalloway, 1925
"...[T]ried in vain to corner it as it scurried about the fringes." ~Michael Dibden, Dead Lagoon, 1994

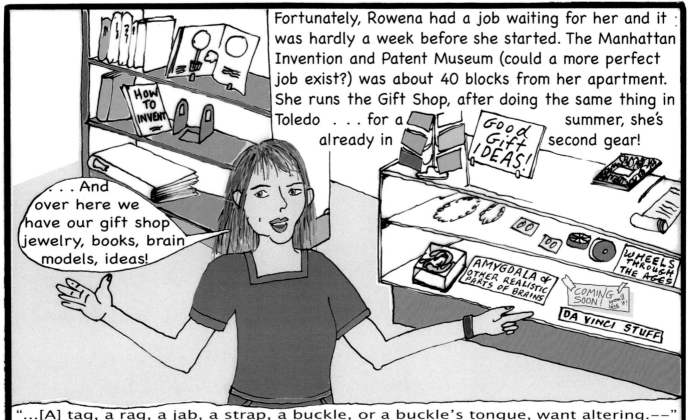

Fortunately, Rowena had a job waiting for her and it was hardly a week before she started. The Manhattan Invention and Patent Museum (could a more perfect job exist?) was about 40 blocks from her apartment. She runs the Gift Shop, after doing the same thing in Toledo . . . for a summer, she's already in second gear!

"...[A] tag, a rag, a jab, a strap, a buckle, or a buckle's tongue, want altering.——"
Laurence Sterne, *The Life and Opinions of Tristram Shandy, Gentleman,* 1759

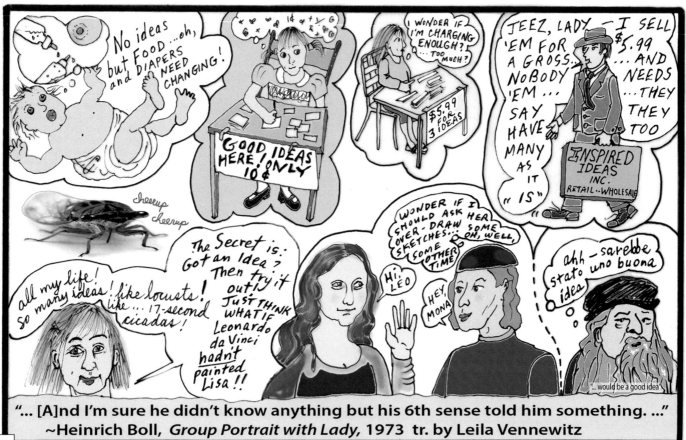

"... [A]nd I'm sure he didn't know anything but his 6th sense told him something. ..."
~Heinrich Boll, *Group Portrait with Lady*, 1973 tr. by Leila Vennewitz

ONE AFTERNOON ON LEXINGTON

Right in front of her, on Lexington Avenue at 30th Street, in front of a restaurant, Rowena saw something awful -- a tiny mouse stuck on a glue trap, tossed into traffic to be finished off. She started crying . . . there were too many trucks to run out and try to save it.

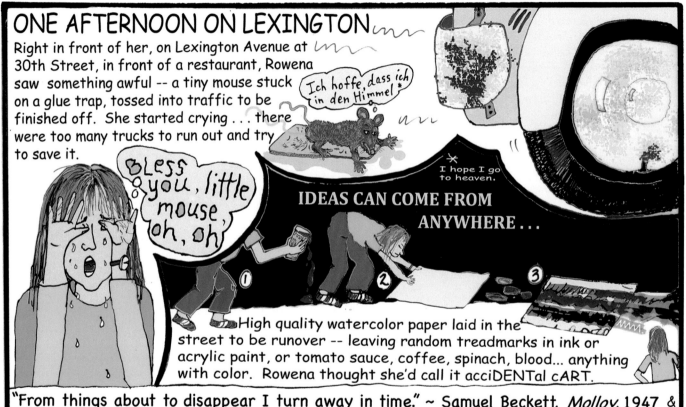

Ich hoffe, dass ich in den Himmel *

✻ I hope I go to heaven.

BLESS you, little mouse, oh, oh

IDEAS CAN COME FROM ANYWHERE . . .

High quality watercolor paper laid in the street to be runover -- leaving random treadmarks in ink or acrylic paint, or tomato sauce, coffee, spinach, blood... anything with color. Rowena thought she'd call it acciDENTal cART.

"From things about to disappear I turn away in time." ~ Samuel Beckett, *Molloy,* 1947 &
"Do you see him? Do you see the story? Do you see anything?" ~ Joseph Conrad, *Heart of Darkness, Part 1,* 1899

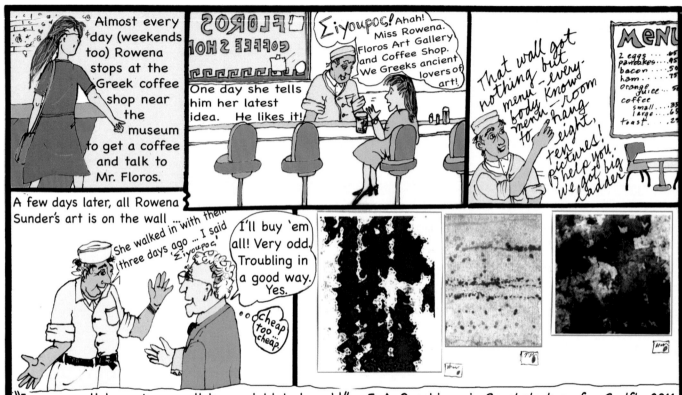

"I am an artist you know ... it is my right to be odd." ~ E. A. Bucchianeri, *Brushstrokes of a Gadfly*, 2011

"... [O]n a 'well-behaved' curve $y = f(X)$, there must be at least one place where the tangent line to the curve is parallel... "

~ Michel Rolle, a French mathematician (1652-1719) wrote the *Mean-Value Theorem*. This is part of it.

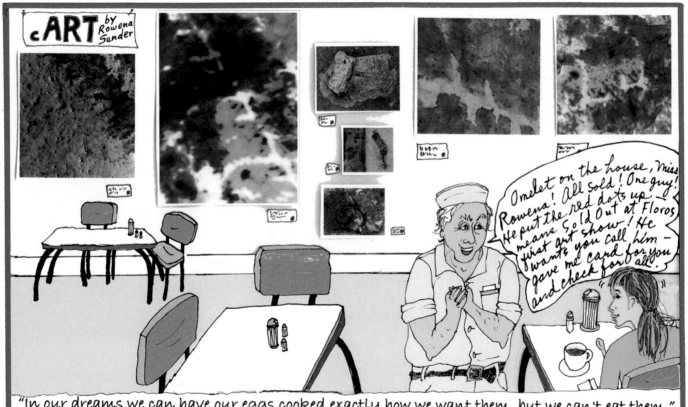

"In our dreams we can have our eggs cooked exactly how we want them, but we can't eat them."
~ Anna Freud, child psychologist, daughter of Sigmund Freud, 1895 - 1983

41

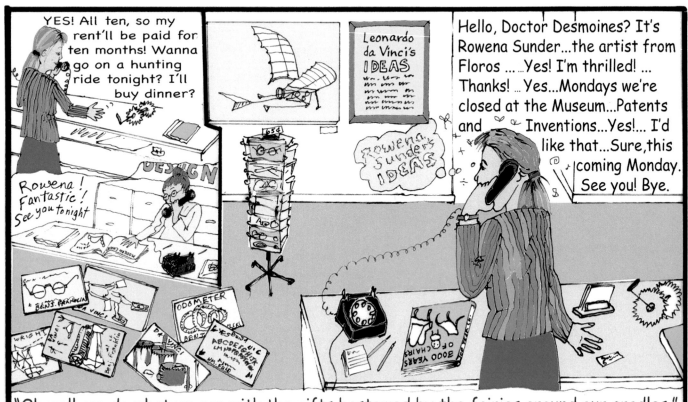

"Oh, well, we do what we can with the gifts bestowed by the fairies around our cradles."
~ Nancy VandenBerg, 2016

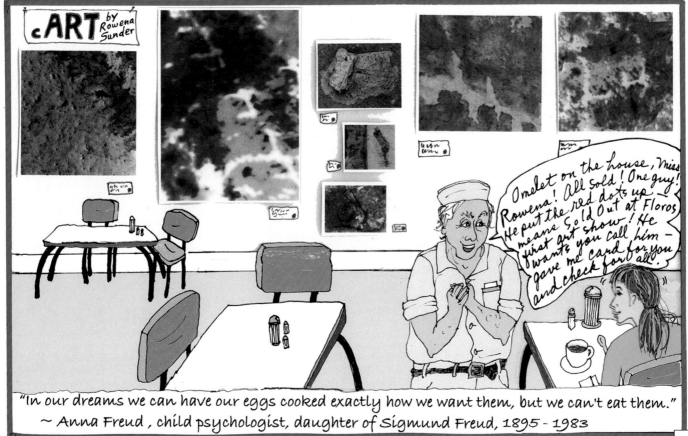

"In our dreams we can have our eggs cooked exactly how we want them, but we can't eat them."
~ Anna Freud , child psychologist, daughter of Sigmund Freud, 1895 - 1983

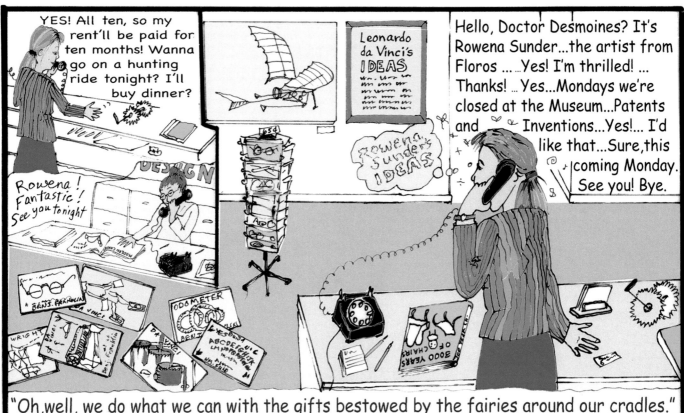

"Oh, well, we do what we can with the gifts bestowed by the fairies around our cradles."
~ Nancy VandenBerg, 2016

Kittyhawk is a terrific cat. He types too. Make of his note what you will (or can). My translation is a first draft and of questionable accuracy.

```
ka8ds 88 [[ ,m.;klm..m
dllgta7y8]4swasaljkssl'a
aljenm kl;k';a.;'   1/ kl/2
ljk890gljkiuL.l    QYU7I
PO)&L:"?<>U 2
```

Probably should be "ate eight roaches" yum

Katydids ate eight! Make 'em diligently wait for wassail, la ahem la la Klack. Icky to lick 890 gladlolas. Question: Why you? Post office and love, Yours, too.

of cheap catsup

Dear M & D,

All 10 cART pictures SOLD at the coffeeshop! Not even framed, just heavy paper. A Dr. Desmoines came & bought all $50 each! He wants me to go to his Park Ave office to talk. He's a psychoanalyst *No. A Psychologist talk Therapist* so that'll be interesting. I'll let you know if Dr. Desmoines thinks I'm crazy. Ha ha. *Hmmm*

I like walking the 42 blocks (2 miles!) to the museum because I get so many ideas. Maybe I'll come up with a million $$ invention! What do we need most?

My friend Nacelina and I bike around & look for thrown-out stuff on Wednesday nights. Don't worry, it's safe. People leave stuff at the curb for garbage pickup. I look for chests of drawers. Drawer bottoms are stiff plus FREE. The "Mona Lisa" is painted on a wood panel; da Vinci would love them. Also found a comfy chair (no bugs) & picture frames. "Something of value" as Dad would say. We went to see the Japanese movie Woman in the Dunes. The entomologist asks the woman "Doesn't all this seem pointless to you? Are you shoveling sand to live or living to shovel sand?" Good question? Exchange any word for Sand and Shovel. "Making Art" "Eating". When we left, my favorite dress was ruined in rain storm -- the colors ran. I should make an "accidental" art picture out of it. The thing about the car runover imprint pictures is I can't control the paper once I put it in the lane of traffic in the street. Again, do not worry, *Love, Rowena*

This is NOT the chair I found. It was here.

"When I first told my parents I was ... going to be an artist, they reacted with alarm."
~ Margaret Atwood, *Cat's Eye*, 1983

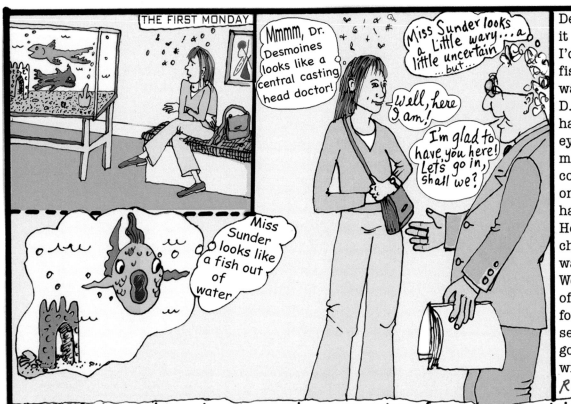

Dear Amie, Well it was just what I'd heard...even a fish tank in the waiting room. Dr. D. looks jovial & has huge unruly eyebrows and a mop of hair. He complimented me on my art...it's hanging all over! He's got a HUGE chair selection. I was very comfy. We'll meet my day off – Mondays – for 45 min; we'll see how long. I'm going to have fun with this. XO
Row(your Boat)s.

"...[L]ife is caught up in a tremendous apparatus of unnecessary strings and tangles." ~ Tom Stoppard, "Tom Stoppard in Conversation," *Vanity Fair*, May 1989

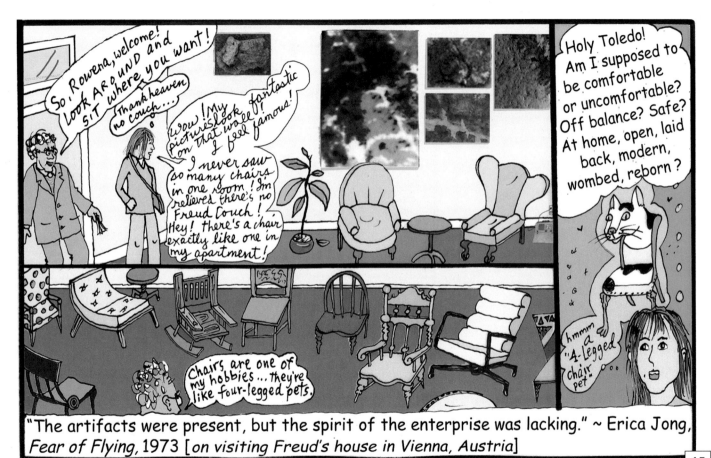

"The artifacts were present, but the spirit of the enterprise was lacking." ~ Erica Jong, *Fear of Flying*, 1973 [*on visiting Freud's house in Vienna, Austria*]

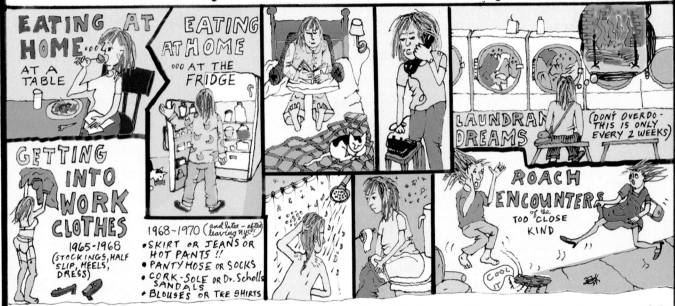

ROWENA'S EVERYDAY SCENES : INSERT WHENEVER

Like most people, Rowena has everyday moments. You can put these wherever, whenever you feel she needs them! Use your imagination!

EATING AT HOME... AT A TABLE

EATING AT HOME ...AT THE FRIDGE

LAUNDRAN DREAMS (DON'T OVERDO - THIS IS ONLY EVERY 2 WEEKS)

GETTING INTO WORK CLOTHES 1965-1968 (STOCKINGS, HALF SLIP, HEELS, DRESS)

1968-1970 (and later - after leaving nyc!!)
• SKIRT OR JEANS OR HOT PANTS !!
• PANTY HOSE OR SOCKS
• CORK-SOLE OR Dr. Scholls SANDALS
• BLOUSES OR TEE SHIRTS

ROACH ENCOUNTERS of the TOO CLOSE KIND

COOL IT

"Too much cleanliness is an enemy to creation...." ~ Robertson Davies. Rebel Angels. 1981
" I like to start working when it's almost too late...when my sense of efficiency is exhausted." Robert Rauschenberg, 1977
"The whole thing of art is, how do you organize chaos?" ~ Romare Beardon, artist, 1911-1988

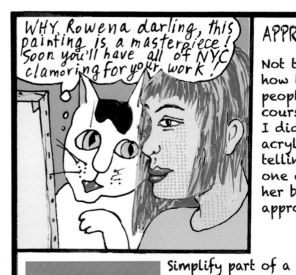

WHY, Rowena darling, this painting is a masterpiece! Soon you'll have all of NYC clamoring for your work!

APPROPRIATION: Borrowing, Stealing, or Setting Aside Funds?

Not too sure what I think of Pop Art! What I don't get is how the artists just want to "appropriate" art from other people and do it over themselves. Lichtenstein and of course Warhol are masters of borrow-and-get-famous! So I did it myself... here is a painting, actually just a quickie acrylic sketch of me with luscious lips and Kittyhawk telling me my painting is soooo good. Lichtenstein did one with a woman with comic book hair and lips telling her boyfriend the same thing. Is this double-down dare or appropriation?

A Motor Rythm can after being Campbell Soup can-onized?

Simplify part of a painting...make it like a Japanese ← woodblock!

Sort of Hiroshige!

Inspiration can come from anything...the lowliest, the highest! Just shake it up and see what comes out!

THE ORIGINAL FUNK UP FORMULA
Whiz

or

Warholimated?

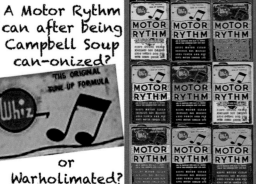

"...the squarish can the olive oil comes in, emblazoned with green-and-gold devices, flowery emblemature out of the 19th century. ... But why am I talking to myself about cans? Cans are not what are troubling me." ~ Donald Barthelme, *Snow White*, 1967 "Adds power and Pep..." ~ Motor Rythm claim, 1940s

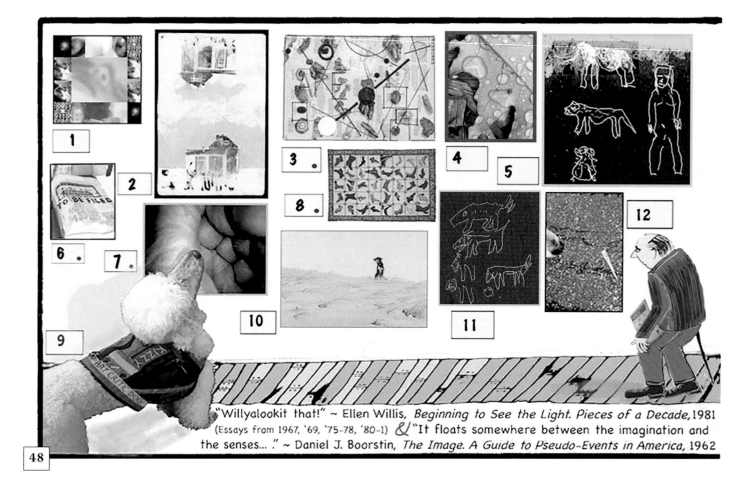

1

2

3 .

4

5

6 .

7 .

8 .

9

10

11

12

"Willyalookit that!" ~ Ellen Willis, *Beginning to See the Light. Pieces of a Decade,* 1981 (Essays from 1967, `69, `75-78, `80-1) & "It floats somewhere between the imagination and the senses... ." ~ Daniel J. Boorstin, *The Image. A Guide to Pseudo-Events in America,* 1962

48

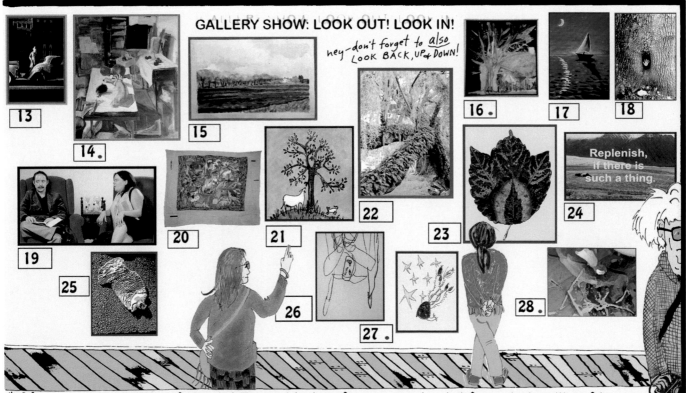

GALLERY SHOW: LOOK OUT! LOOK IN!

hey—don't forget to also LOOK BACK, UP & DOWN!

Replenish, if there is such a thing.

13　14.　15　16.　17　18　19　20　21　22　23　24　25　26　27.　28.

"...]I]mage is a pure creation of the mind. It cannot be born from a comparison but from a juxtaposition of two more or less distant realities. The more distant and true...the stronger the image." ~ Pierre Reverdy, *Nord-Sud*, March 1918

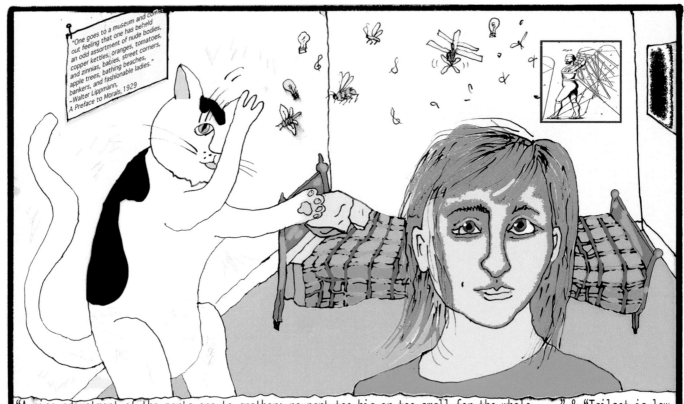

"One goes to a museum and comes out feeling that one has beheld an odd assortment of nude bodies, copper kettles, oranges, tomatoes, and zinnias, babies, street corners, apple trees, bathing beaches, bankers, and fashionable ladies."
–Walter Lippmann, 1929
A Preface to Morals,

"A nice adjustment of the parts one to another; no part too big or too small for the whole... ." & "Tailset is low, and hindleg is very straight of stifle."~ Anna Katherine Nicholas, *The Nicholas Guide to Dog Judging,* 1970

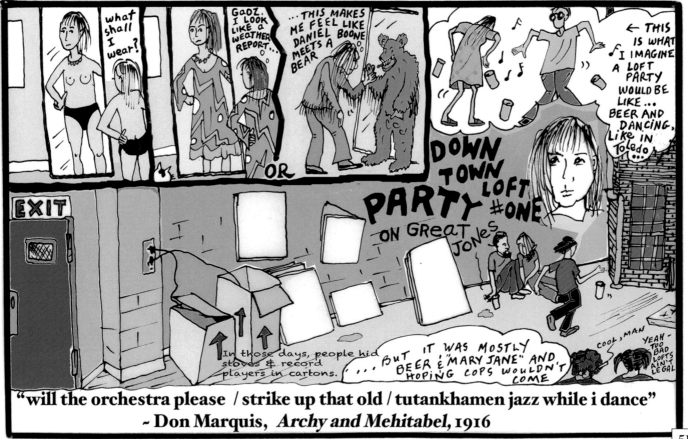

"will the orchestra please / strike up that old / tutankhamen jazz while i dance"
~ Don Marquis, *Archy and Mehitabel,* 1916

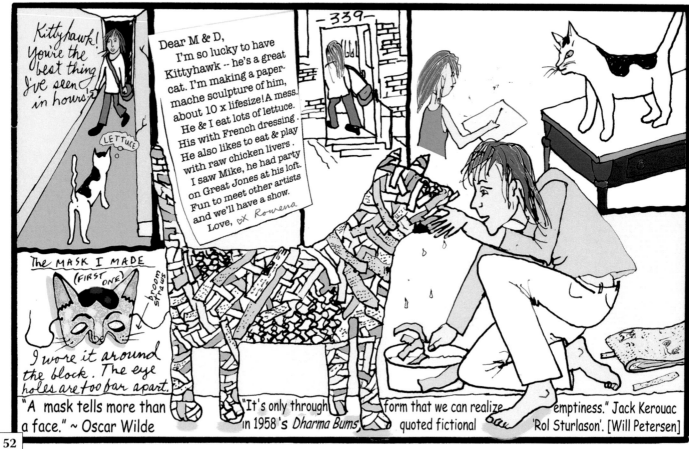

"Focusing isn't just an optical activity, it is also a mental one." ~ Bridget Riley, op artist

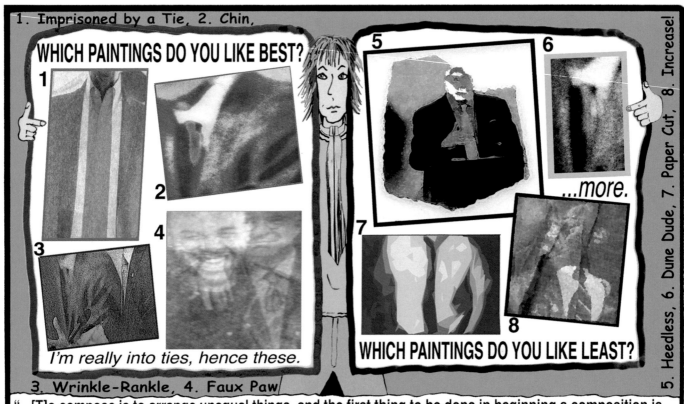

WHICH PAINTINGS DO YOU LIKE BEST?

I'm really into ties, hence these.

...more.

WHICH PAINTINGS DO YOU LIKE LEAST?

"...[T]o compose is to arrange unequal things, and the first thing to be done in beginning a composition is to determine which is to be the principal thing." ~ John Ruskin, 1819-1900 (prolific critic of art, architecture & society)

Dear Amie, Share with friends. I've begun more work on ties...they're every-where. Guys & Ties ... title?

I may hang a few ptgs in another group show. Not sure when exactly. I still owe Dr. D. a ptg for his some-times helpful conversations. Mostly we talk about what "focus" is & means. Do I wish I had more of it? I think I'm glad I have less. He says I shouldn't worry..An artist's brain isn't the same as the brain of a scientist. Really? We had a great discussion last Monday about shapes & imagination and memory, which can be ephemeral.

More later... blockhead
your friend,
xx
Rowena
← in case I run out of paintbrushes

& - "Guys' Guise"?

FOCUS? Dr. Desmoines (Psychologist) & Rowena (Artist) discuss yet again. A short 8mm movie was made of this talk:
D: As critics say, you don't have a recognizable oeuvre... every few pictures you change the theme. **R:** I can't think of anything more boring that 100 variations on a theme..even Bach's Goldberg Variations has only um 30. I can't do just one thing. **D:** Tell me about these ideas you get... **R:** In again out again, out of the blue, they come from the right, behind my ear, bore through my head and leave a vision... painting, story, you know. Happens everywhere. **D:** How long has this been happening? **R:** Forever, at least since kindergarten. **D:** Are you so sure it *is* a problem? You could train yourself to focus , it's in there -- in your brain to focus. Like a frog trying to catch bugs. Work on "eating" your ideas to digest them, getting nourishment from them, until they can't get away....

"... [P]lace a looking-glass first in a chair on one side of it...." ~ Laurence Sterne, *The Life and Opinions of Tristram Shandy,* 1759
"...[A]lways five hundred periods after each sentence." ~ Jack Kerouac, *"The Roaming Beatniks, Holiday Magazine,* Oct. 1959

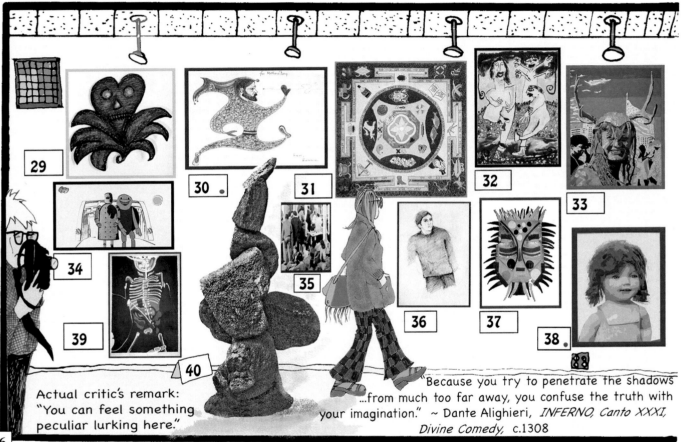

29

30

31

32

33

34

35

36

37

38

39

40

Actual critic's remark: "You can feel something peculiar lurking here."

"Because you try to penetrate the shadows ...from much too far away, you confuse the truth with your imagination." ~ Dante Alighieri, *INFERNO, Canto XXXI, Divine Comedy*, c.1308

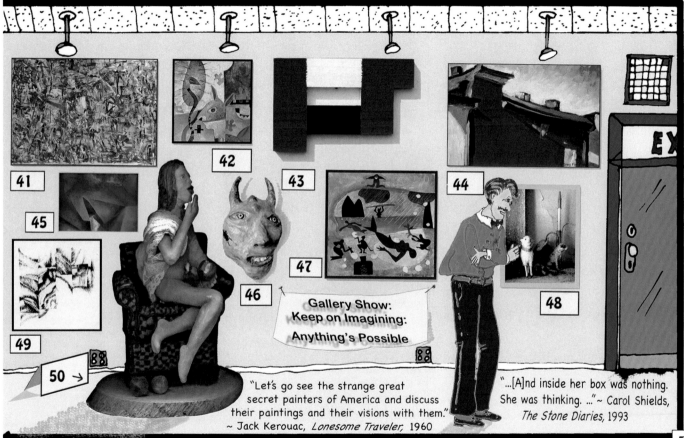

41

42

43

44

45

46

47

48

49

50 →

Gallery Show:
Keep on Imagining:
Anything's Possible

"Let's go see the strange great secret painters of America and discuss their paintings and their visions with them." ~ Jack Kerouac, *Lonesome Traveler,* 1960

"...[A]nd inside her box was nothing. She was thinking. ..."~ Carol Shields, *The Stone Diaries,* 1993

EX

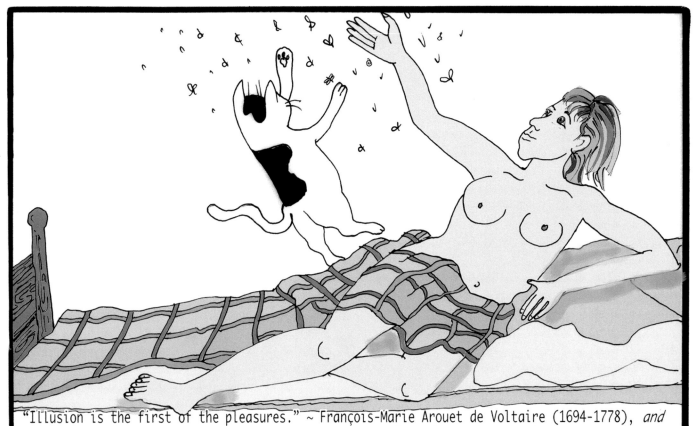

"Illusion is the first of the pleasures." ~ François-Marie Arouet de Voltaire (1694-1778), *and*
"Imagination is the Discovering Faculty, pre-eminently." ~ Ada Lovelace, written January 5, 1841

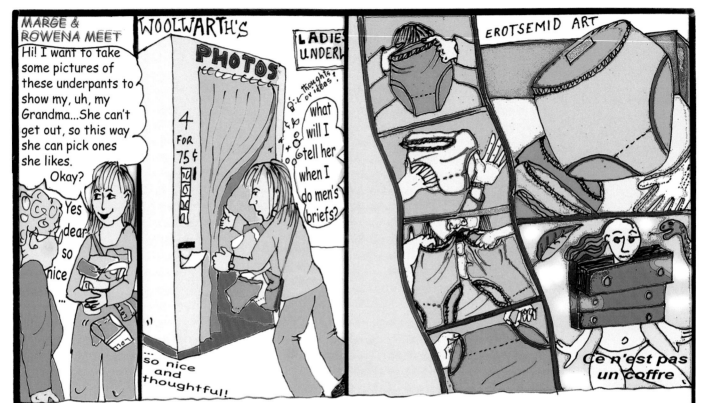

"The young ladies entered the drawing-room in the full fervour of sisterly animosity."
~ Robert Smith Surtees, *Mr. Sponge's Sporting Tour,* 1849

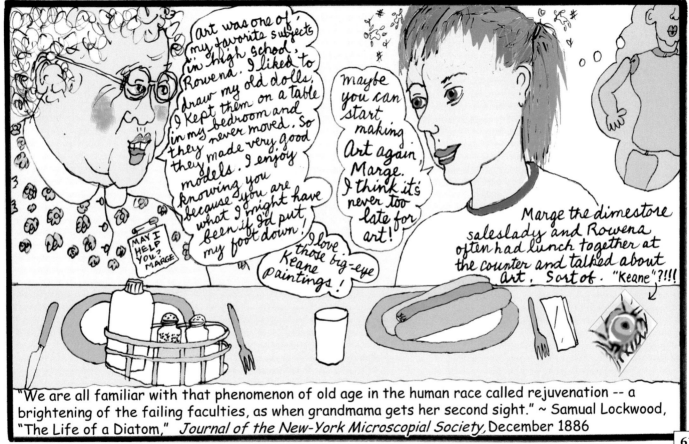

"We are all familiar with that phenomenon of old age in the human race called rejuvenation -- a brightening of the failing faculties, as when grandmama gets her second sight." ~ Samual Lockwood, "The Life of a Diatom," *Journal of the New-York Microscopial Society,* December 1886

61

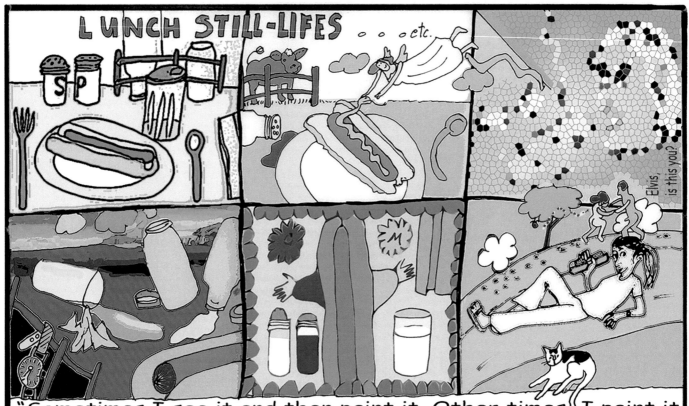

"Sometimes I see it and then paint it. Other times I paint it and then see it." ~ Jasper Johns, 1959 for *Sixteen Americans* show at MOMA

"Wait! Wait! You don't get it! I was extremely impatient to know what would follow the ominous oracle... ." ~ Denis Diderot (1713-1784)

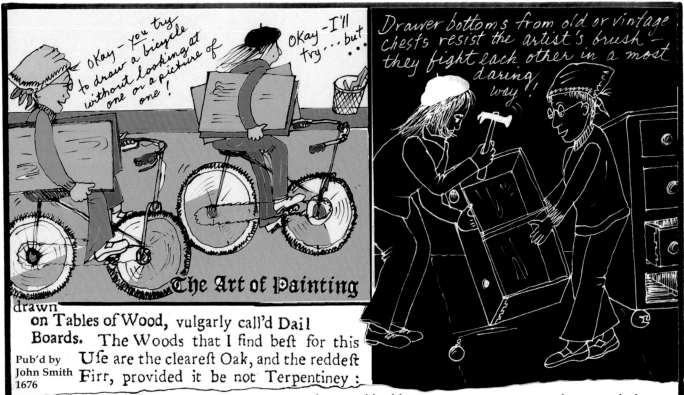

The Art of Painting

drawn on Tables of Wood, vulgarly call'd Dail Boards. The Woods that I find best for this Use are the clearest Oak, and the reddest Firr, provided it be not Terpentiney :

Pub'd by John Smith 1676

"I want my street to be crazy, I want my avenues, shops and buildings, to enter into a crazy dance, and this is why I deform and distort their outlines and colours." ~ Jean Dubuffet, *"Prospectus et tous écrits suivants,"* Vol. 'II,' 1967

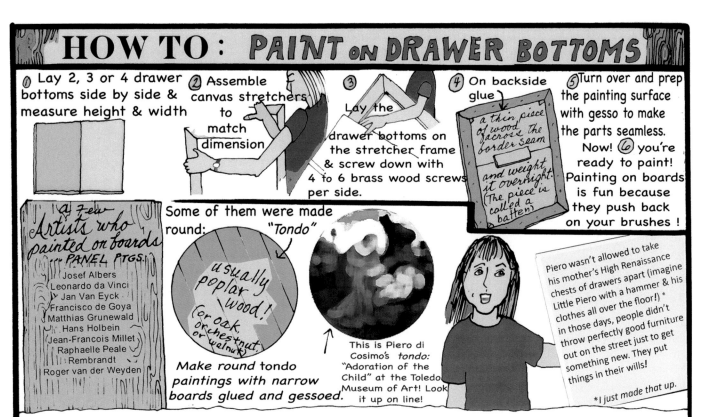

HOW TO: PAINT on DRAWER BOTTOMS

① Lay 2, 3 or 4 drawer bottoms side by side & measure height & width

② Assemble canvas stretchers to match dimension

③ Lay the drawer bottoms on the stretcher frame & screw down with 4 to 6 brass wood screws per side.

④ On backside glue a thin piece of wood across the border seam and weight it overnight. The piece is called a batten.

⑤ Turn over and prep the painting surface with gesso to make the parts seamless. Now! ⑥ you're ready to paint! Painting on boards is fun because they push back on your brushes!

A few Artists who painted on boards — PANEL PTGS.

Josef Albers
Leonardo da Vinci
Jan Van Eyck
Francisco de Goya
Matthias Grunewald
Hans Holbein
Jean-Francois Millet
Raphaelle Peale
Rembrandt
Roger van der Weyden

Some of them were made round: "Tondo"

usually poplar wood! (or oak, or chestnut, or walnut)

Make round tondo paintings with narrow boards glued and gessoed.

This is Piero di Cosimo's *tondo*: "Adoration of the Child" at the Toledo Museum of Art! Look it up on line!

Piero wasn't allowed to take his mother's High Renaissance chests of drawers apart (imagine Little Piero with a hammer & his clothes all over the floor!) * in those days, people didn't throw perfectly good furniture out on the street just to get something new. They put things in their wills!

*I just made that up.

"I remembered in pictures, some quite still, some full of motion, none of them rectangular."
~ Harold Brodkey, "A Story in an Almost Classical Mode," *New Yorker*, September 17, 1973

Perhaps you are wondering if Rowena ever beds down with anyone but Kittyhawk? Does she ever have a romantic interlude? So many ideas for Art, but no dates? No boyfriends? Fill scenes in when you think she could really use a kiss or a hug, or something more.

"The next thing that happened...happened in the dark." ~ John Barth, *The Floating Opera*, 1956

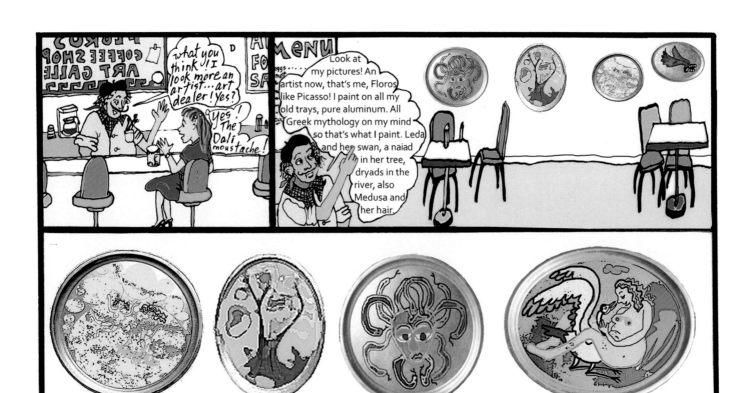

DRYADS at PLAY IN RIVER NAIAD IN HER TREE MEDUSA with GREEK SNAKES LEDA AND HER SWAN CHARMER

"Is one born an artist or does one become an artist?" ~ José Saramago, *Manual of Painting & Calligraphy*, 1976. Tr. by Giovanni Pontiero

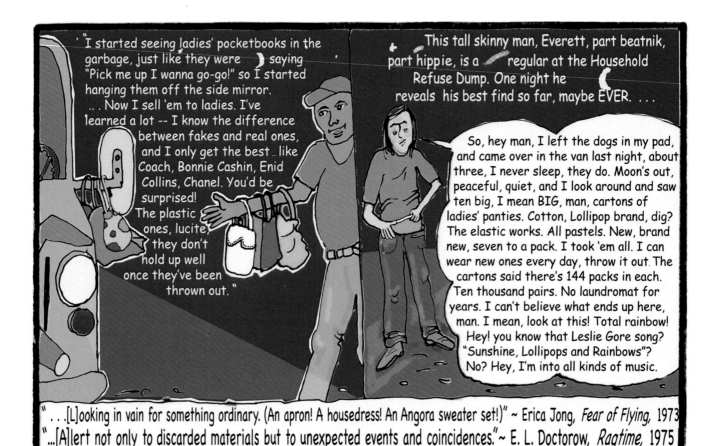

" ...[L]ooking in vain for something ordinary. (An apron! A housedress! An Angora sweater set!)" ~ Erica Jong, *Fear of Flying*, 1973

"...[A]lert not only to discarded materials but to unexpected events and coincidences."~ E. L. Doctorow, *Ragtime*, 1975

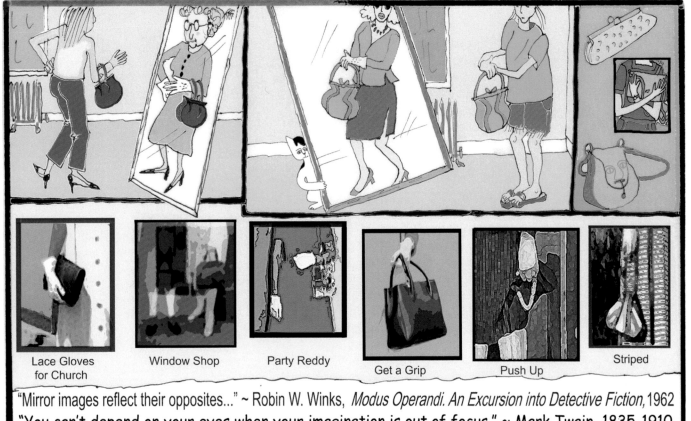

Lace Gloves
for Church

Window Shop

Party Reddy

Get a Grip

Push Up

Striped

"Mirror images reflect their opposites..." ~ Robin W. Winks, *Modus Operandi. An Excursion into Detective Fiction,* 1962

"You can't depend on your eyes when your imagination is out of focus." ~ Mark Twain, 1835-1910

69

Dear Rowena, I'm finally finding time to write you about Toledo news. Three people in our class have moved away ---Roberta went to San Francisco and has a job at a coffee house during the evenings, and says she's painting beach scenes during the day. She can't swim. Mark was drafted & will be sent to a training camp down South, He's scared, but relieved to have something decided for him "FATE." Marty's in Chicago, at the museum in restoration department I think. I can't imagine spending my day trying to fix up a Lucien Freud wearing extremely strong magnifying glasses, but it's possible that's not what she does. Ha! There'll be lots of work for her in 20 years. I don't get the idea of just letting your paintings decompose after spending time composing them. I read about "Process" artists who say that putting the paint on canvas IS the art, no matter what happens to it later. You said on the phone that you're painting everyday things? Is that sort of Pop Art with comic books or cans like Warhol? He said that Pop was stuff anybody would "recognize in a split second" -- the "masses" as he said. But do the "Masses" buy art? Exciting about your runover stuff selling. Should I bring my stuff to Mr. Floros to sell in his coffee shop. Amie

Dear Amie -- Sorry I don't write you much, you can maybe take the train to visit. Toledo isn't that far away! I showed some of my pocketbook paintings at a group show & the review in the Voice said "women like things that hold other things." I want to know does he mean brains or wombs? Are "handbags" -- the NYC term -- too bourgeois. I did sell one -- I was glad for the $ (not much tho!) I really like to do pictures of everything that seems overlooked: Doing a series of men's ties, don't know what else ... yet

"Sears, the Dog"

Dear Amie, here is a picture of a dog assemblage I made last week. I found a really beat-up drill and took it apart & made it into a dog's head. The ears are part of a baseball I found in the street. I can't stop doing stuff I never did before. Guess it's part of the focus thing.

"A fool there was and he made his prayer/ (Even as you and I!)/ To a rag and a bone and a hank of hair?/ (We called her the woman who did not care)/ But the fool he called her his lady fair ..." ~ Rudyard Kipling, *The Vampire,* 1897

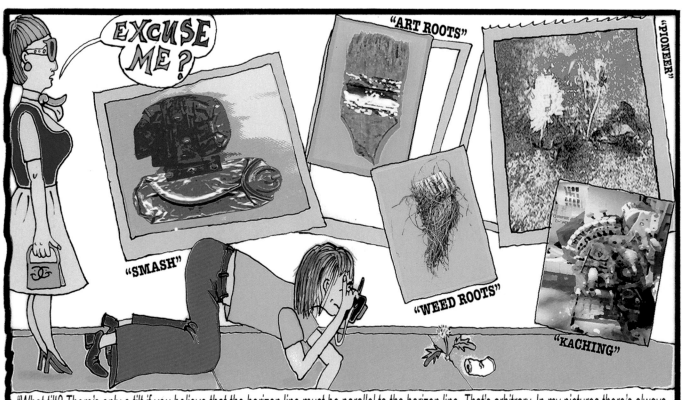

"What tilt? There's only a tilt if you believe that the horizon line must be parallel to the horizon line. That's arbitrary. In my pictures there's always something parallel to the horizontal edge and that rationalizes the photograph." ~ Gary Winograd, American Photographer 2, no. 5, May 1979

So much is thrown out or lost on the streets of Manhattan! Well, Queens, Brooklyn, the Bronx, and Staten Island too. Runover and rusted. Squashed and rotted. Rowena is out there on the weekends with her Rediflex, usually near her apartment or near work. Some pictures are good for paintings. Street Stills or maybe STREET STILL LIVES.

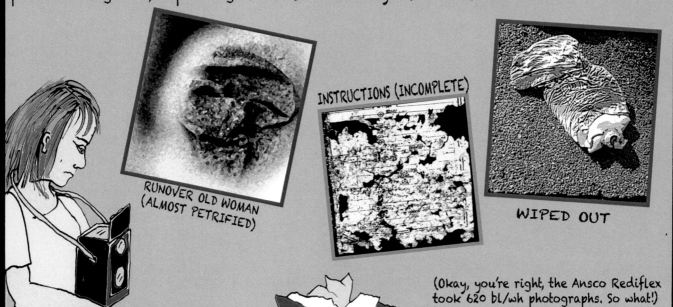

RUNOVER OLD WOMAN (ALMOST PETRIFIED)

INSTRUCTIONS (INCOMPLETE)

WIPED OUT

(Okay, you're right, the Ansco Rediflex took 620 bl/wh photographs. So what!)

"We do not begin to comprehend the telepathic power of things." ~ Norman Mailer, "The Faith of Graffiti", *Esquire*, 5/1974 and "Stop! It might be Something of Value!" ~ Robert Dumont Franklin, 1977

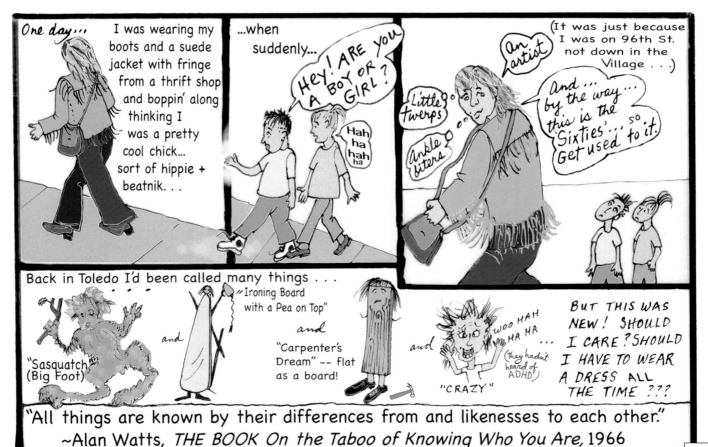

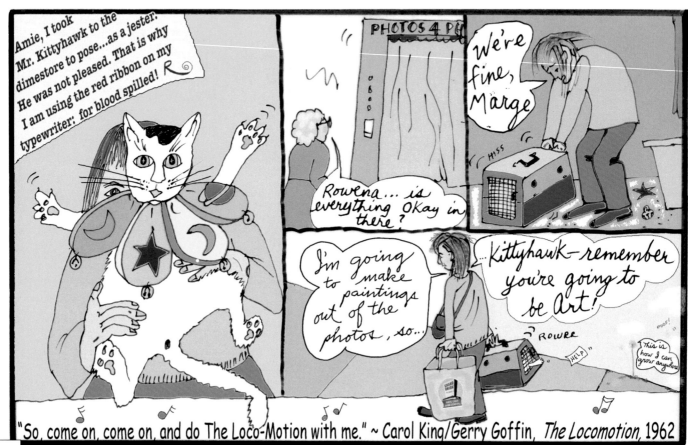

"So, come on, come on, and do The Loco-Motion with me." ~ Carol King/Gerry Goffin, *The Locomotion*, 1962

74

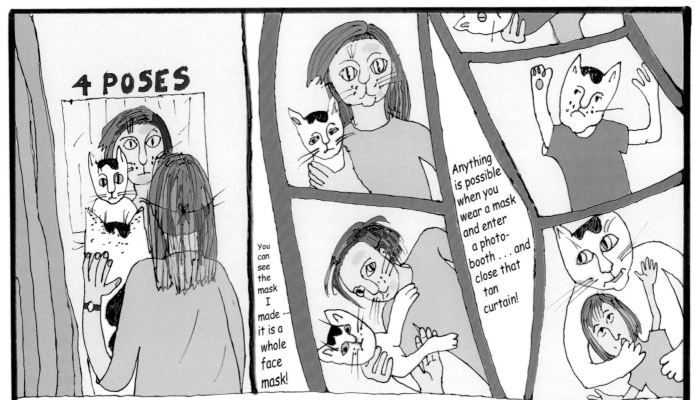

"Hey household pet/ Work hard/ Do a good job." ~ Adam Robinson, *"Poem Bag"*, 2010
"The new alchemical dream is: changing one's personality--remaking, remodeling, elevating, and polishing one's very self...
~ Tom Wolfe, *Mauve Gloves & Madmen, Clutter & Vine,* 1976

This is my page. I seemed like an accident to Rowena (and to you?) but dang it, I deserve to say what's on my mind. Artists have used my sort for their purposes for a long time. Rowena found me and laid me down on a shelf and forgot me (until now). To you, I may look like the face of a wrinkled, angry old person who has been badly treated -- dropped off to wither away. Rust to Dust (as I like to say). But I refuse. (Don't you think it is interesting that while the word REFUSE as a verb means to deny a request, as a noun it means trash or waste matter? In other words, something that has been denied?) I will not be denied! I am not refuse! I am a sculptural object crushed, runover, rusted, ignored, and set aside. Keep looking at me . . . see me as the head and neck of a quizzical young chicken; a fat fish with a big fin! Turn me upside down and I'm _____whatever! Now go look up *pareidolia* and *simulacrum* !

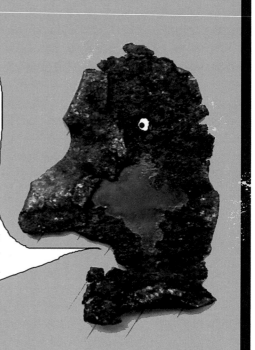

"It made no difference; every thing I saw, or had to do with, touch'd upon some secret spring either of sentiment or rapture." ~ Laurence Sterne, *The Life and Opinions of Tristram Shandy, Gentleman,* 1759

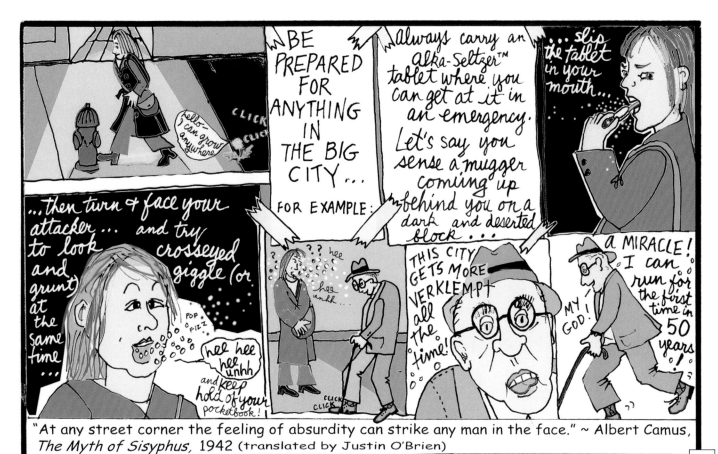

"At any street corner the feeling of absurdity can strike any man in the face." ~ Albert Camus, *The Myth of Sisyphus*, 1942 (translated by Justin O'Brien)

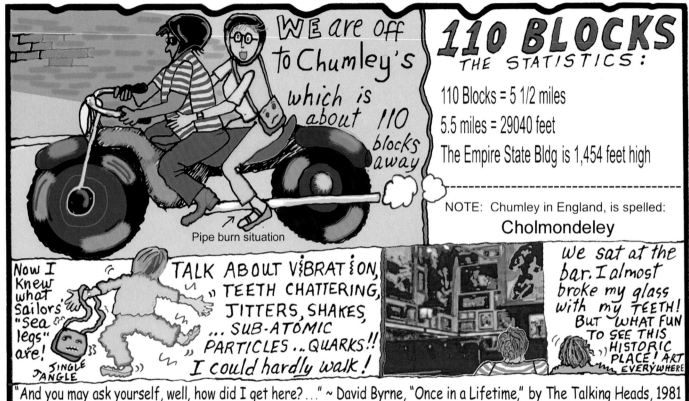

We are off to Chumley's which is about 110 blocks away

Pipe burn situation

110 BLOCKS
THE STATISTICS:

110 Blocks = 5 1/2 miles

5.5 miles = 29040 feet

The Empire State Bldg is 1,454 feet high

NOTE: Chumley in England, is spelled:
Cholmondeley

Now I knew what Sailors' "Sea legs" are! JINGLE JANGLE

TALK ABOUT VIBRATION, TEETH CHATTERING, JITTERS, SHAKES, ... SUB-ATOMIC PARTICLES ... QUARKS!! I could hardly walk!

We sat at the bar. I almost broke my glass with my TEETH! BUT WHAT FUN TO SEE THIS HISTORIC PLACE! ART EVERYWHERE

"And you may ask yourself, well, how did I get here? ..." ~ David Byrne, "Once in a Lifetime," by The Talking Heads, 1981

"The only place the fourth can be is round at the back" ~ Berthold Brecht, *Galileo, a Play*, tr. by Charles Laughton, 1940

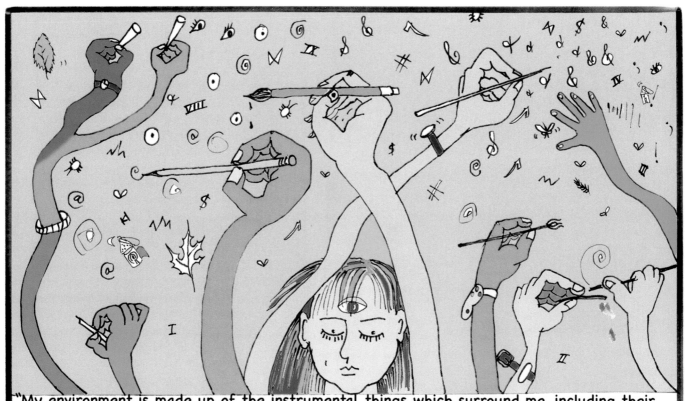

"My environment is made up of the instrumental things which surround me, including their peculiar coefficients of adversity and utility." ~ Jean-Paul Sartre, *Being and Nothingness*, 1943
This translation by Hazel E. Barnes, 1963

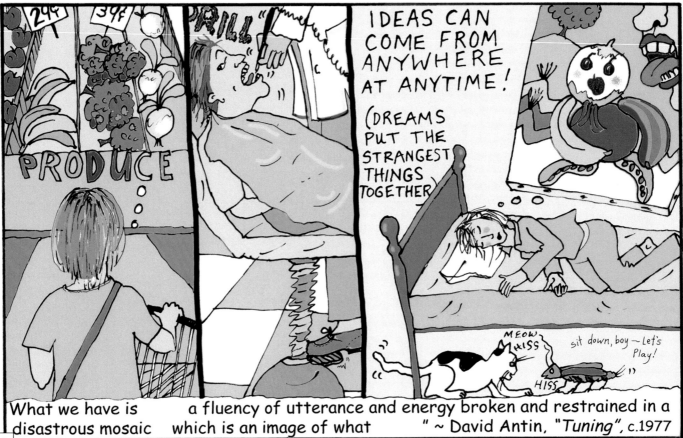

What we have is disastrous mosaic a fluency of utterance and energy broken and restrained in a which is an image of what " ~ David Antin, "Tuning", c.1977

So, Amie, today's subject is triangles. I told you about Mom getting upset about a triangle in a self-portrait I did where my legs at the canvas's base formed a triangle? I made a triangle painting that Dr. D pointed out was symbolic -- the Trinity & the crotch. Mom was on to something. Carl Jung (Symbol Man), wrote of triangles... some kind of Eastern religious symbols. I found out that Dan Flavin who has been making art with light for a few years said "A piece of wall can be visually disintegrated from the whole into a separate triangle by plunging a diagonal of light from edge to edge on the wall; that is, side to floor, for instance." I have always loved the way light coming in windows is so angular...Maybe I'll paint some new paintings with•••

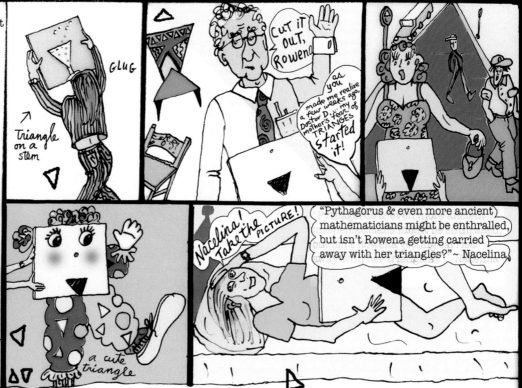

GLUG

Triangle on a stem

CUT iT OuT, Rowena

as you made me realize a few weeks ago, Doctor D....my mother's fear of TRIANGES started it!

a cute triangle

Nacelina! Take the PICTURE!

"Pythagorus & even more ancient mathematicians might be enthralled, but isn't Rowena getting carried away with her triangles?" ~ Nacelina

"It is perfectly true, as philosophers say, that life must be understood backwards. But they forget the other proposition, that it must be lived forwards." ~ Søren Kierkegaard, *Journals,* 1836-37

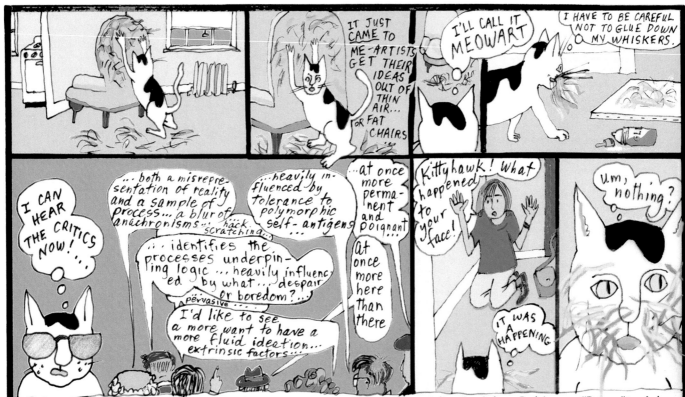

"I had just returned from work and my legs were too tired to really socialize." ~ Adam Robinson, "Poem" in *Adam Robison and Other Poems,* 2010 *&* "...[L]ooked like nothing so much as evicted furniture." ~ Lucy R. Lippard, "Beauty and the Bureaucracy", *Hudson Review* XX-4 Winter 1967-8

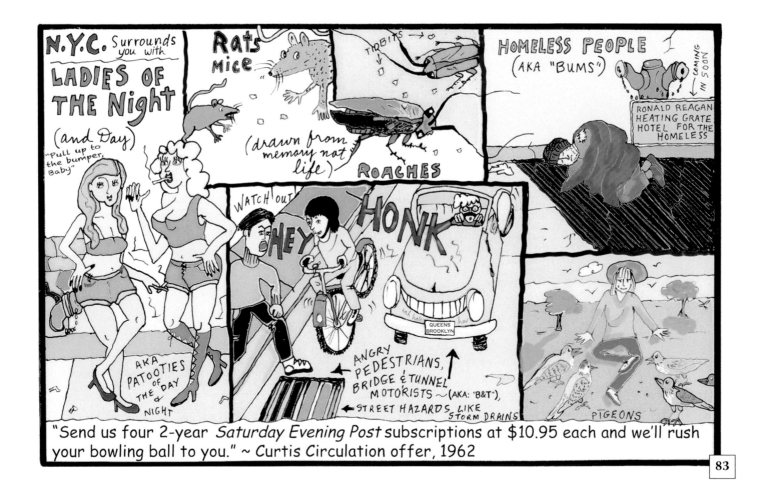

"Send us four 2-year *Saturday Evening Post* subscriptions at $10.95 each and we'll rush your bowling ball to you." ~ Curtis Circulation offer, 1962

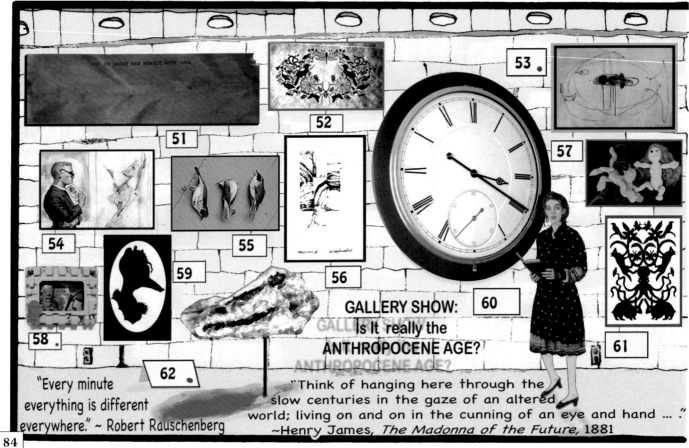

GALLERY SHOW:
Is It really the
ANTHROPOCENE AGE?

"Every minute
everything is different
everywhere." ~ Robert Rauschenberg

"Think of hanging here through the
slow centuries in the gaze of an altered
world; living on and on in the cunning of an eye and hand"
~Henry James, *The Madonna of the Future*, 1881

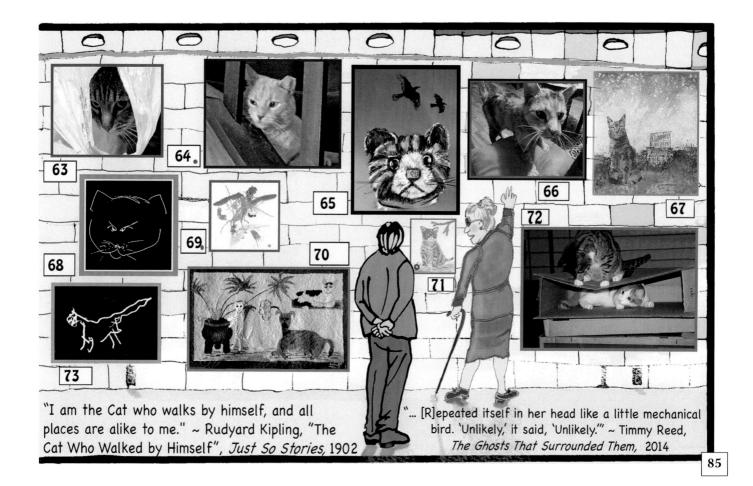

63

64

65

66

67

68

69

70

71

72

73

"I am the Cat who walks by himself, and all places are alike to me." ~ Rudyard Kipling, "The Cat Who Walked by Himself", *Just So Stories,* 1902

"… [R]epeated itself in her head like a little mechanical bird. 'Unlikely,' it said, 'Unlikely.'" ~ Timmy Reed, *The Ghosts That Surrounded Them,* 2014

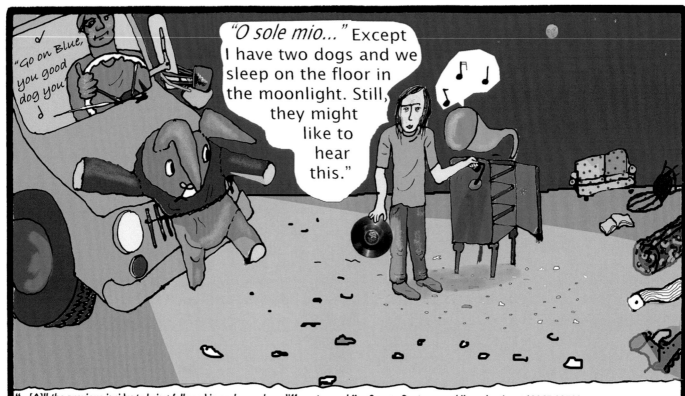

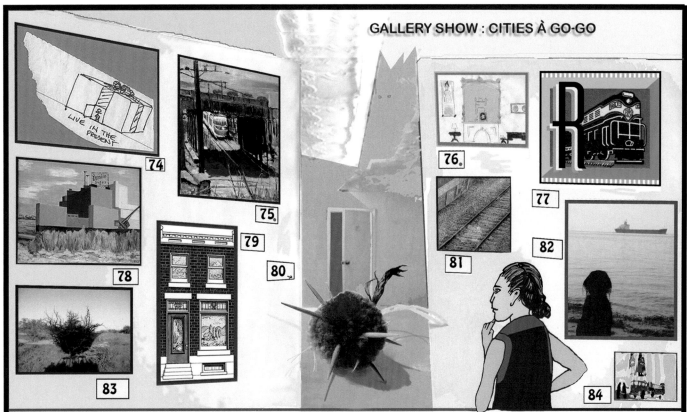

74

75

76

77

78

79

80

81

82

83

84

"The rhyme they create when looked at together alters the reality of each." ~ Paul Auster, *The Invention of Solitude,* 1982 ♂ an actual critic's remark: "... a diffuse feeling of difference."

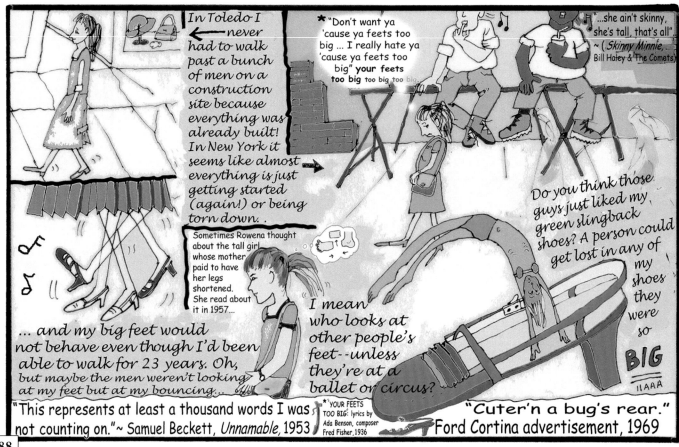

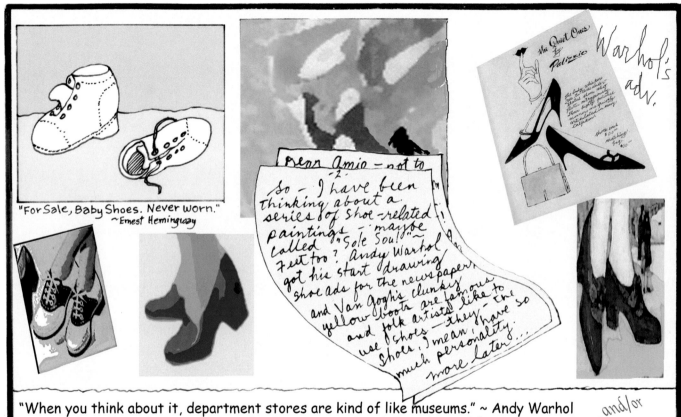

"For Sale, Baby Shoes. Never worn."
~Ernest Hemingway

"When you think about it, department stores are kind of like museums." ~ Andy Warhol
"Live in Enna Jetticks -- and Like It! ... Every pair is hand-flexed." ~ ad for Enna Jetticks Shoes, 1930s

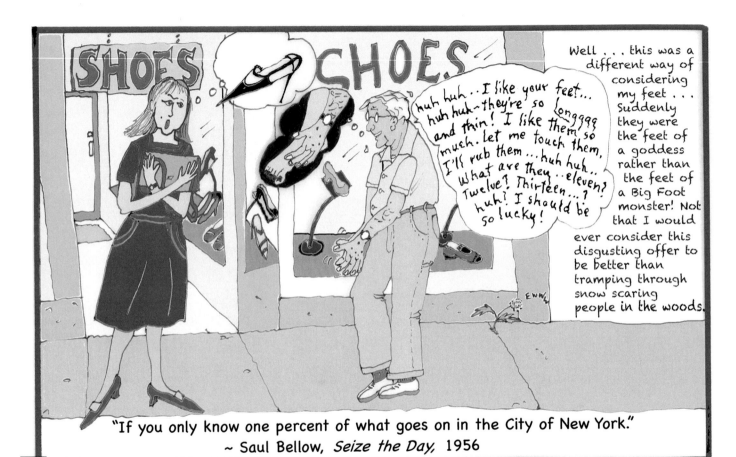

"If you only know one percent of what goes on in the City of New York."
~ Saul Bellow, *Seize the Day*, 1956

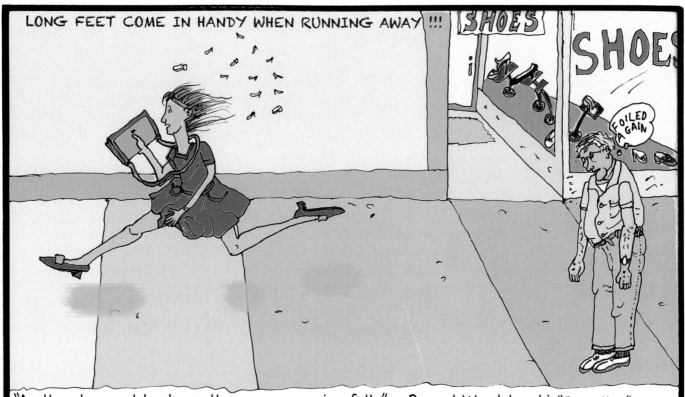

"As the abnormal beckons, the savory evening falls." ~ Rupert Wondolowski, *"Opposites,"* in *Ancient Party, Collaborations in Baltimore, 2000-2010*, ed. by Megan McShea, 2014

USE YOUR IMAGINATION TO PAINT THESE!!

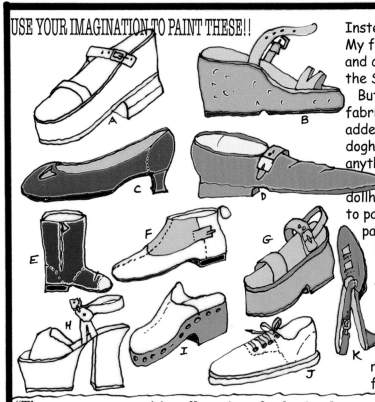

Instead of painting shoes, I decided to paint shoes. My favorite shoes to paint (G) were cheap leather and cork-soled platform sandals from S. Klein on the Square and from Alexander's basement.

But I painted all kinds -- leather, fake leather, fabric. Women's shoes and boots and men's. I also added stuff -- glued on rhinestones, plastic dogs & doghouses, bones, Barbie heads and hands, bells, anything! I found mini objects of every kind at B. Shackman's store near Union Square (lots of dollhouse things and other miniatures). I wanted to paint legs too, but nobody wanted their legs painted (except at Electric Circus). When you look at the next page, you'll see one of my LEGends, painted on a mannequin leg.

Because of the Vietnam War, somehow I got the idea that the fashion industry would do weird stuff with bandages and army boots and missing limbs, etc. You'll see a little on the next page. I wasn't right about that, but then, I was hardly a fashionista of any kind!

"The passages or cavities allow air to freely circulate underneath the false sole and up through the various holes in it." ~ Lyman Daggett. *"Improved Inner Sole,"* Patent 55,247, June 5, 1866

92

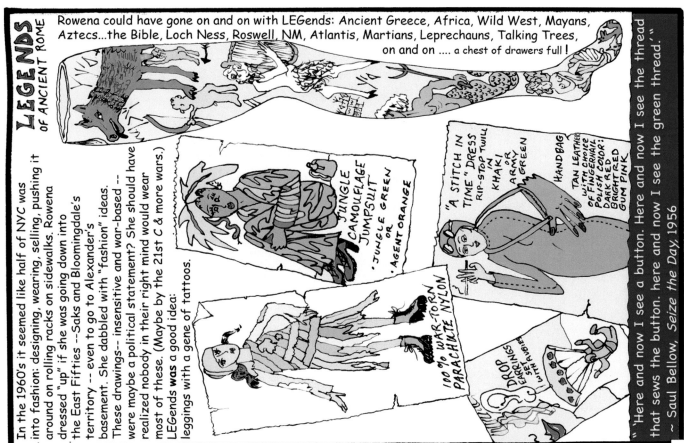

Rowena could have gone on and on with LEGends: Ancient Greece, Africa, Wild West, Mayans, Aztecs...the Bible, Loch Ness, Roswell, NM, Atlantis, Martians, Leprechauns, Talking Trees, on and on a chest of drawers full !

In the 1960's it seemed like half of NYC was into fashion: designing, wearing, selling, pushing it around on rolling racks on sidewalks. Rowena dressed "up" if she was going down into the East Fifties --Saks and Bloomingdale's territory -- even to go to Alexander's basement. She dabbled with "fashion" ideas. These drawings-- insensitive and war-based -- were maybe a political statement? She should have realized nobody in their right mind would wear most of these. (Maybe by the 21st C & more wars.) LEGends **was** a good idea: leggings with a gene of tattoos.

JUNGLE CAMOUFLAGE JUMPSUIT
• JUNGLE GREEN
OR
• AGENT ORANGE

100% WAR-TORN PARACHUTE NYLON

"A STITCH IN TIME" DRESS
RIP-STOP TWILL
IN
KHAKI
OR
ARMY GREEN

HANDBAG
TAN LEATHER
WITH CHOICE
OF FINGERNAIL
POLISH COLOR:
DARK RED
BRIGHT RED
GUM PINK

DROP EARRINGS
SET WITH RUBIES

"Here and now I see a button. Here and now I see the thread that sews the button. here and now I see the green thread."
~ Saul Bellow, *Seize the Day*, 1956

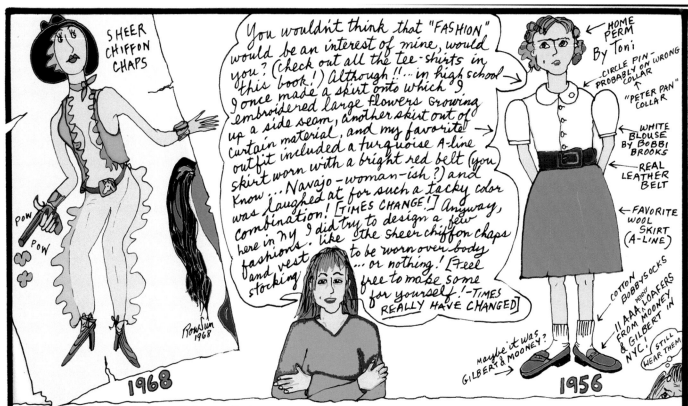

"'Haven't you got something a little more unusual?' And then the saleslady would bring out all the weird colors no one else would buy-- ..." ~ Erica Jong, *Fear of Flying,* 1973

Hello BOB! I hope you're okay, and all the stuff going on over there isn't so horrible as it seems in the newspaper. I got your letter last week about the heat in the jungle. When we were little, it seems like the "jungle" was one of the best places to be because everything always came out all right. Tarzan was a wild (feral) little runaway who made friends with animals, and Rudyard Kipling wrote a whole jungle book. There was a book about another feral boy, Mowgli or something? Happy monkeys swinging on vines, and friendly tigers, etc. I know it's not like that.

I look at LIFE magazine every week, almost always a cover story about the war. I search the faces for men I might know.

Rowena

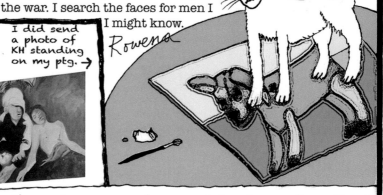

I didnt send him a picture of the Pietà-like painting I did from a LIFE magazine cover. All of them are so heart-wrenching. All those wasted lives. I try to write Bob at least once a week. I hope this war becomes the one to "end all wars" but doubt it.

I did send a photo of KH standing on my ptg. →

We owe a lot to the soldiers, and also to the photographers -- who are often right in the middle. We wouldn't know what happens without both.

"... [H]aunted , not by reality, but by those images we have put in place of reality."
~ Daniel J. Boorstin, *The Image. A Guide to Pseudo-Events in America*, 1962.

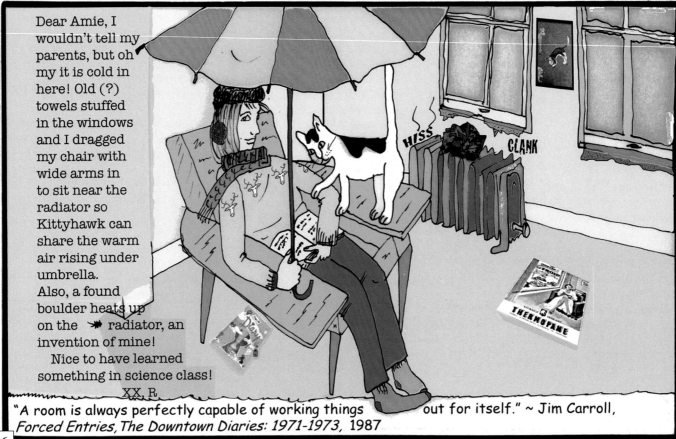

Dear Amie, I wouldn't tell my parents, but oh my it is cold in here! Old (?) towels stuffed in the windows and I dragged my chair with wide arms in to sit near the radiator so Kittyhawk can share the warm air rising under umbrella. Also, a found boulder heats up on the ⟫⟫ radiator, an invention of mine!

Nice to have learned something in science class!

XX, R

HISS

CLANK

THERMOPANE

"A room is always perfectly capable of working things out for itself." ~ Jim Carroll, *Forced Entries, The Downtown Diaries: 1971-1973,* 1987

Hi, Amie, I wish you could be here with Nacelina & me for our late night get-togethers at the local coffee bar. Tonight we discussed how different circles of people overlap in so many ways. I made a diagram of how it works. Looked like a solar system!

We go to this place 'cuz coffee is cheap & it's dark enough we don't have to look any better than we do.

A strange guy here who we talk to is probably 30, and his "business" is painting miniature lead soldiers. I wonder if anyone wants Vietnam soldier minis. My subletter Bob wrote me. So far he's okay, but two of his buddies were injured badly. I write him weekly.

Nacelina and I go down to St. Marks Place every weekend or so...she likes to look at old clothes, kinda like when I used to buy stuff at Toledo's army surplus. I've been a few times to the Electric Circus -- fabulous place with live music. Sly & The Family Stone the best yet.!!!

"My nourishment is refined from the ongoing circus of the mind in motion."
~ Donald Barthelme, *Snow White,* 1967

97

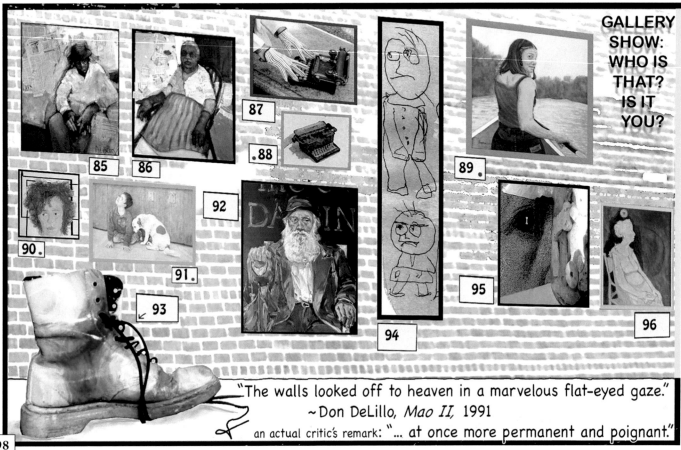

GALLERY SHOW: WHO IS THAT? IS IT YOU?

85
86
87
88
89
90
91
92
93
94
95
96

"The walls looked off to heaven in a marvelous flat-eyed gaze."
~Don DeLillo, *Mao II,* 1991
an actual critic's remark: "... at once more permanent and poignant."

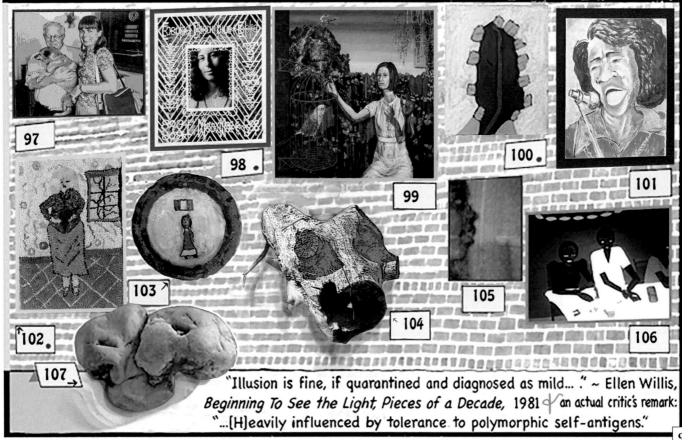

97
98
99
100
101
102
103
104
105
106
107

"Illusion is fine, if quarantined and diagnosed as mild... ." ~ Ellen Willis, *Beginning To See the Light, Pieces of a Decade,* 1981 / an actual critic's remark: "...[H]eavily influenced by tolerance to polymorphic self-antigens."

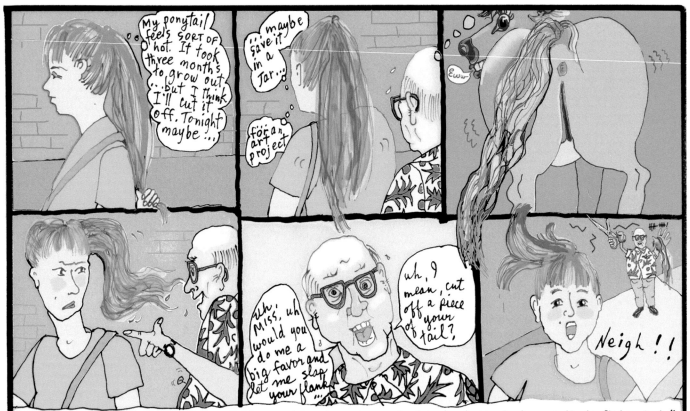

"...[T]he girls suddenly become all hips and heels and people try to dance between their flying hair."
~ Jack Kerouac, *Lonesome Traveler,* 1960

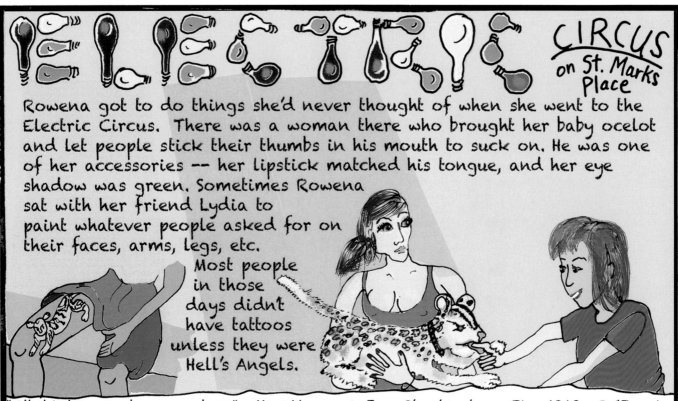

ELECTRIC CIRCUS on St. Marks Place

Rowena got to do things she'd never thought of when she went to the Electric Circus. There was a woman there who brought her baby ocelot and let people stick their thumbs in his mouth to suck on. He was one of her accessories -- her lipstick matched his tongue, and her eye shadow was green. Sometimes Rowena sat with her friend Lydia to paint whatever people asked for on their faces, arms, legs, etc.

Most people in those days didn't have tattoos unless they were Hell's Angels.

"All this happened, more or less." ~ Kurt Vonnegut, Jr., *Slaughterhouse Five,* 1968 ... & "I can't just turn off my Art and be normal for a few days." ~ Slangston Hughes, *"Quantum Leap,"* 2012

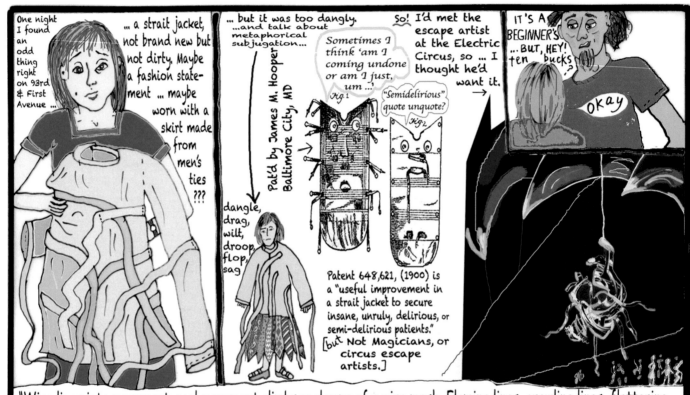

"Wire lines into movement, real movement climbs real rope of a wire mesh. Flaming lines, crawling lines, flattering lines crossed." ~ Kurt Schwitters, *Anna Blume ...I Demand the MERZ-Stage,"* 1919. Tr. by Michael Bullock

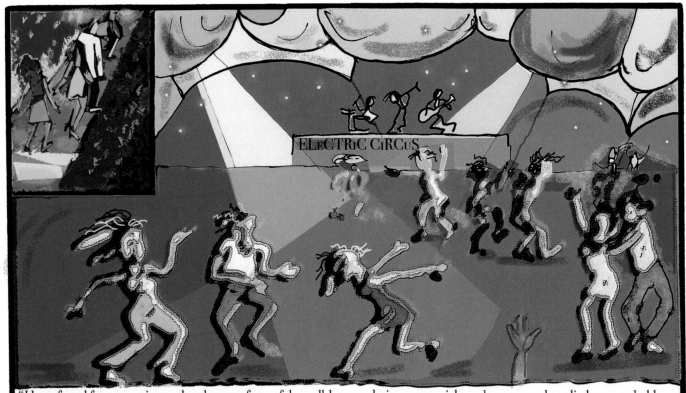

"I have found from experiment that the use of any of the well-known glutinous materials ... alone cannot be relied upon to hold the stalks tightly in a mass or wisp." ~ John E. Phillips, *"Improvement in Preparing Wisps for Brooms,"* Patent 54,591, May 8, 1866

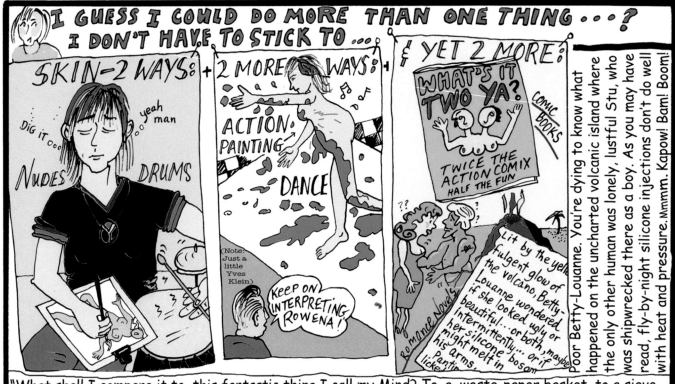

"What shall I compare it to, this fantastic thing I call my Mind? To a waste-paper basket, to a sieve choked with sediment, or to a barrel full of floating froth and refuse? No, what it is really most like is a spider's web ... " ~ Logan Pearsall Smith, *Trivia*, 1902

"I might have room enough to explain the nature of the perplexities." ~ Laurence Sterne, *Tristram Shandy*, 1759

Dear M & D, Remember the linoleum cut I did of your shoe rug? It is going to appear as a "spot" in Saturday Review! I got $75 for it. Wow! Was I or wasn't I destined to be a New Yorker? Didn't I grow up with three mags? National Geographic, Sat. Review, & The New Yorker? (Plus the Peach Section in the Blade!, my favorite.) Some of my ideas are as persistent as Eustace Tilley's butterfly. I draw a lot of cartoons & covers for the NY'r & walk them over on my lunch hour, and get them back, rejected, a week later when I drop off more. I guess Eustace isn't paying attention. I think of things, and try to make them funny but my best ones, ha ha, are either about that guy on top of a mountain or the doomsday guy ~~day guy~~ walking around, and the NY'r gets plenty of those I guess. I am sending you four cover sketches.

"Commuting"

"ReCycle"

"Rooked Again"

"Hangin' Loose"

-2-
The ideas: I bet many roaches (ants?) ride in gym shoe soles. Developer$ play chess or poker? with buildings. Nacelina & I save great stuff. I wonder if any balloons in the Macy's T'giving Parade wish to to be elsewhere --a children's book, floating in the sky with birds! More later, Love, Rowena

...[T]he only sound being the 'SKRITCH-SKRITCH' of steel nips on paper." L. K. Hanson, "Some Pages from the Story of My Hand," *Ploughshares,* Fall 2012 and/or "She heard the scratch scratch of the steel drawing pens." ~ E. L. Doctorow, *Ragtime,* 1975

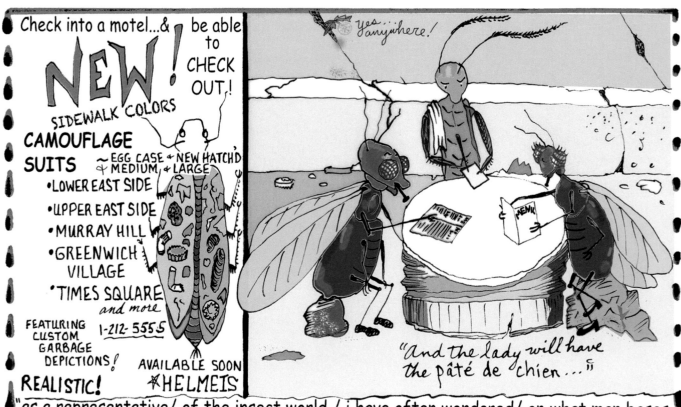

yes...yanywhere!

"And the lady will have the pâté de chien ..."

"as a representative/ of the insect world / i have often wondered/ on what man bases his claims/ to superiority .." ~ Don Marquis, *the wisdom of archy*, circa 1927

107

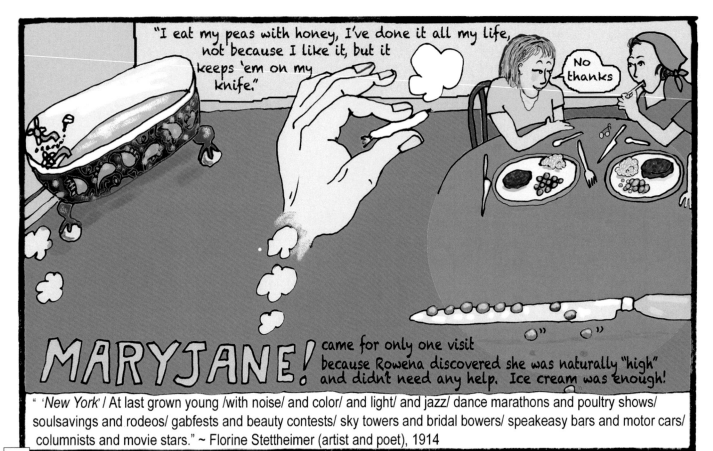

"I eat my peas with honey, I've done it all my life, not because I like it, but it keeps 'em on my knife."

No thanks

MARYJANE! came for only one visit because Rowena discovered she was naturally "high" and didn't need any help. Ice cream was enough!

" 'New York' / At last grown young /with noise/ and color/ and light/ and jazz/ dance marathons and poultry shows/ soulsavings and rodeos/ gabfests and beauty contests/ sky towers and bridal bowers/ speakeasy bars and motor cars/ columnists and movie stars." ~ Florine Stettheimer (artist and poet), 1914

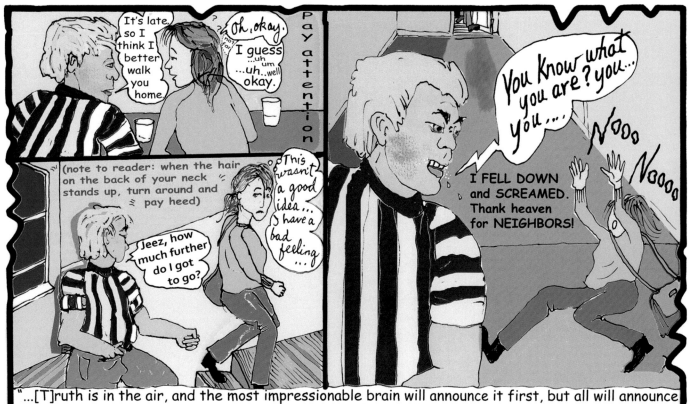

One night – and it was a Saturday after an "outing" down to St. Marks Place ~ by herself, Rowena was driving her bug back uptown. It was very late and she was glad that there was very little traffic.

DARK BUT NOT STORMY

She decided to beat the light at 14th and First Avenue. Out of Nowhere (which surely is a place) ...suddenly... came a cab... ...from the east !

... and suddenly – WHAM! – Rowena was upside down in the bug. The cabbie called the police ...

MISS, MISS, ARE YOU OKAY?

and first the police then an ambulance and . . .

Rowena (with a gash on top of her head -- her Hard Head, "Your head so hard!") was whisked to Bellevue Hospital (shorthand for where "crazy" people in NYC were confined) and rolled into a room filled with beds filled with patients. A nurse shaved, swabbed her head and pushed a threaded needle in...

...her scalp, to sew up the split... and suddenly there were sirens and the nurse said "Hold still and I'll be back as soon as possible..." This gave Rowena the chance to ponder being "crazy" at Bellevue!

An hour or so later, the 22 stitches were finished and Rowena took a cab home. Ahhh! no more parking, no more filling stations! The VW was R I P

"I am relying on these lights, as indeed all other similar sources of credible perplexity, to help me continue and perhaps even conclude." ~ Samuel Beckett, *The Unnamable,* 1954

110

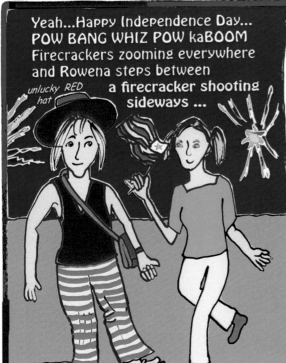

Yeah...Happy Independence Day...
POW BANG WHIZ POW kaBOOM
Firecrackers zooming everywhere
and Rowena steps between
unlucky RED
hat
a firecracker shooting
sideways ...

...between two cars and her friend Barbara POW! BANG! it doesn't hit Barbara, but cuts right through her new pants and into her leg. She can't look at it. They have to go somewhere. The choice is between a bar & St. Mark's Church on the Bowery...equidistant. They choose the bar, and the hunky bartender kneels down and bandages Rowena's leg. This is not something Rowena will write home about ... or to Bob, in Vietnam. Next 4th of July, she'll stay home, up on 94th. What if it had hit an artery? What if she had leaned over to pick up a penny at just that moment and it hit her in the eye. POW! That's what happened to people. Her Dad never did anything more exciting than light one of those snakes that sizzled on the patio. And let her run around in the dark with sparklers! The boy across the street had blown off most of his right hand with a cherry bomb.

JET DRAGON SNAKE
SAFE & SANE
6.Pcs
NON/POISONOUS

"Insert the igniter of the match in the match-case, ..., and introduce as a bursting charge a small quantity of fulminate of mercury, or gun-cotton which has been saturated in a solution of potassa or gunpowder. Close the ends with cement." ~ Jabez B. Dowse, "Apparatus for Exploding by Electricity" Patent No 68,055, Aug. 27, 1867

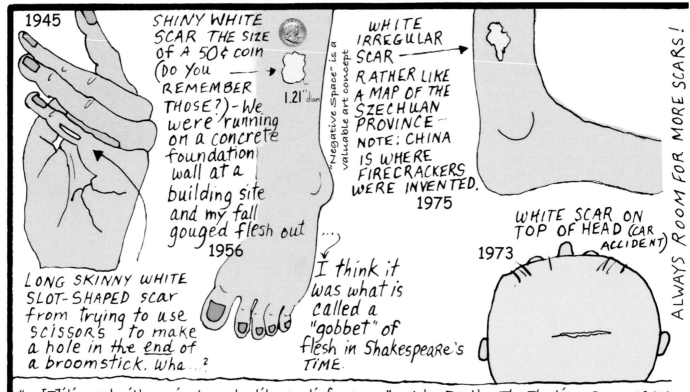

1945

SHINY WHITE SCAR THE SIZE OF A 50¢ COIN (DO YOU REMEMBER THOSE?) - We were running on a concrete foundation wall at a building site and my fall gouged flesh out 1956

1.21" diam

"Negative space" is a valuable art concept

WHITE IRREGULAR SCAR → RATHER LIKE A MAP OF THE SZECHUAN PROVINCE - NOTE: CHINA IS WHERE FIRECRACKERS WERE INVENTED. 1975

LONG SKINNY WHITE SLOT-SHAPED SCAR from trying to use SCISSORS to make a hole in the end of a broomstick. Wha...?

... I think it was what is called a "gobbet" of flesh in Shakespeare's TIME.

WHITE SCAR ON TOP OF HEAD (CAR ACCIDENT)

1973

ALWAYS ROOM FOR MORE SCARS!

"... [F]iligreed with ancient cracks like a relief map...." ~ John Barth, *The Floating Opera*, 1967
"One must allow that a certain amount of carelessness in one's nature often accomplishes what the will is incapable of doing." ~ Jane Bowles, *Two Serious Ladies*, 1943

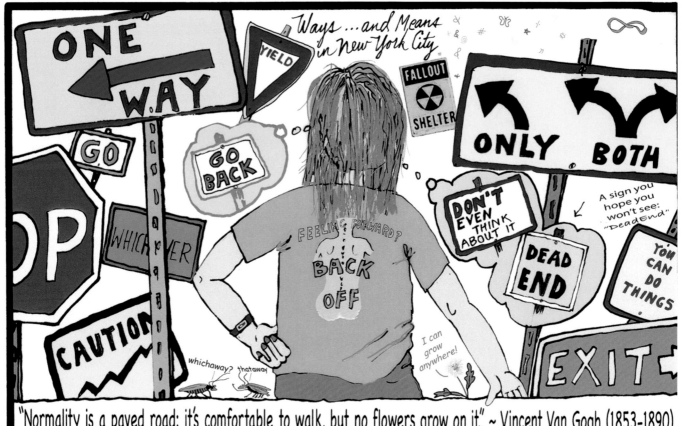

"Normality is a paved road: it's comfortable to walk, but no flowers grow on it." ~ Vincent Van Gogh (1853-1890)

TRANSPORTATION IN N.Y.C.

ear Amie -- Since my car was totalled, I take the subway or bus and/or bike/walk. Bus for cross-town, subway for speed. The only bad thing is sardine-can cramming. You keep 'holt' of pockets, pocketbooks, and your apparently irresistable behind. One of my old nick-names, one of the better ones, was "Buns". **1.**

HANG ON!

LURCH

HOLLER

cram bam thank you, ma'am

On the 1st & 2nd Ave bus, there's sometimes a man with no legs who rolls in the aisle on a board with skate wheels. He sings and we put coins in his money can. Gosh. **2.**

3. I've already told you about our bike adventures, mostly at night. I hate to carry the bike down dressed for work. You'd love the stuff we find! Have you tried painting on drawer bottoms? it's fun. Look at the rondo in the Cloister. Wow! I have done five now It's great FUN! × R

The VW Bug has been smashed. Sqush. (Squush?). Friends know but not the parents, who would only worry -- more than they do. She saves on gas, on time to find parking. Public transportation in NY is so good and varied. She's been thinking about telling them she sold the car. They will ask.

"...[T]here is no space except space between things, inside things, or outside things."
Alan Watts, *THE BOOK On the Taboo of Knowing Who You Are*, 1973

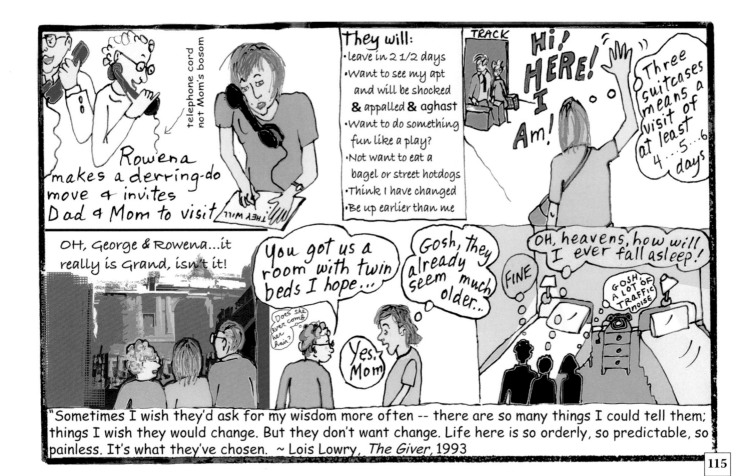

"Sometimes I wish they'd ask for my wisdom more often -- there are so many things I could tell them; things I wish they would change. But they don't want change. Life here is so orderly, so predictable, so painless. It's what they've chosen. ~ Lois Lowry, *The Giver*, 1993

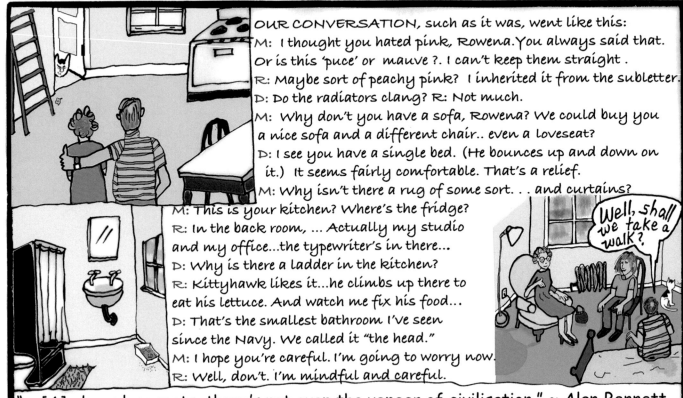

"... [A]nd no place mats, there's not even the veneer of civilisation." ~ Alan Bennett, "Her Big Chance" 1988, in *The Complete Talking Heads,* 1998

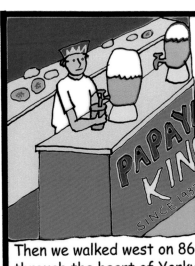

We walked down to 86th Street to Papaya King to get juice. M&D had never even heard of papaya juice, so they shared a small one, then got two big ones. Dad ate his hotdog like a little boy, and pronounced it "Surprisingly Tasty" and then bought and ate a second one.

At least they're having fun!

George, dear, don't eat so fast! You'll get the burps!

Then we walked west on 86th through the heart of Yorkville, where Mom wanted to stop and buy a big box of marzipan candies in the shape of everything from frogs to the Statue of Liberty. "Gifts" she assured me. "Not any for me, please," I told her.

FINALLY they chose to take a taxi back to the Biltmore to "rest" before dinner, i.e., two hour naps and respite for me. Parents can be very exhausting!

BURP

SNORE

"Time gives us something to do with our minds when we aren't thinking." ~ Dwight Macdonald, *Masscult and Midcult: Essays Against the American Grain,* 1957

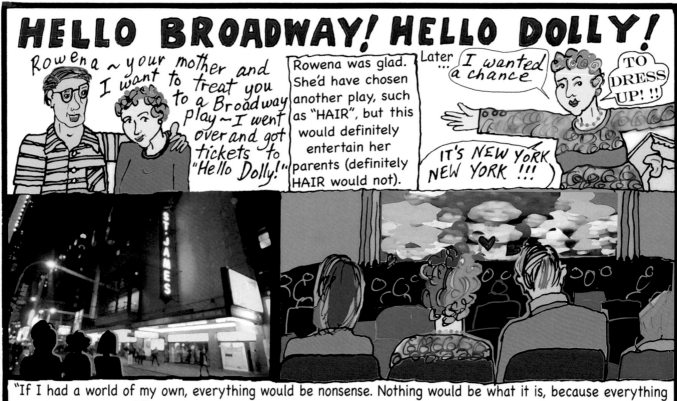

HELLO BROADWAY! HELLO DOLLY!

Rowena ~ your mother and I want to treat you to a Broadway play ~ I went over and got tickets to "Hello Dolly!"

Rowena was glad. She'd have chosen another play, such as "HAIR", but this would definitely entertain her parents (definitely HAIR would not).

Later... I wanted a chance

TO DRESS UP! !!

IT'S NEW YORK NEW YORK !!!

"If I had a world of my own, everything would be nonsense. Nothing would be what it is, because everything would be what it isn't." ~Lewis Carroll (Charles Lutwidge Dodgson) *Alice's Adventures in Wonderland,* 1865 &
"The place of solitude where three dreams cross/ Between blue rocks." ~ T. S. Eliot, *Ash Wednesday,* 1930

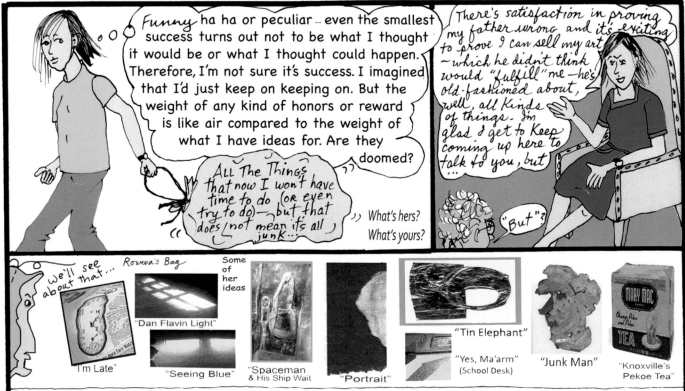

"People commonly travel the world over to see rivers and mountains, new stars, garish birds, freak fish, ...; they fall into an animal stupor that gapes at existence and they think they have seen something."
~ Søren Kierkegaard, *Either/Or: A Fragment of Life*, 1834

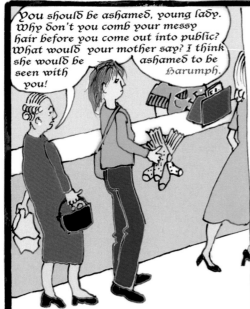

You should be ashamed, young lady. Why don't you comb your messy hair before you come out into public? What would your mother say? I think she would be ashamed to be seen with you!

Harumph.

I was in the dimestore buying socks. The old lady behind me was buying underpants. Her hair looked glued on. Precise!

Where is MARGE when I need Motherly defense?

Don't flip your wig...

Used to comments, I just smiled and said nothing.

I still have the socks; I'll bet the underpants are long gone. Why do people buy so-called "flesh color" underwear? And what is "flesh color" anyway?

etc. etc.

In 1962, Crayola completed changing the 1903 crayon color to Peach. It had been Flesh and Pink Beige. "Flesh" is the blood-filled muscle & fat UNDER the skin. Flesh is what "flesh-eaters" eat -- you know, lions, tigers, he-men! I bet there's a small customer base for actual "flesh-color" underpants and bras. What is the chance that there is a woman (or man) alive who is flesh-colored!!! Well, doll makers make up their own skin colors too. Coloring the book has been fun coming up with skin tones.

I still have that hair. It's no worse and no better. My mother never said anything!

"You have to do stuff that average people don't understand." ~ Andy Warhol & & & & & & "...[L]iked to see underwear drying on the line the wind animating it to a maniac dance." ~ E. L. Doctorow, *Loon Lake,* 1963

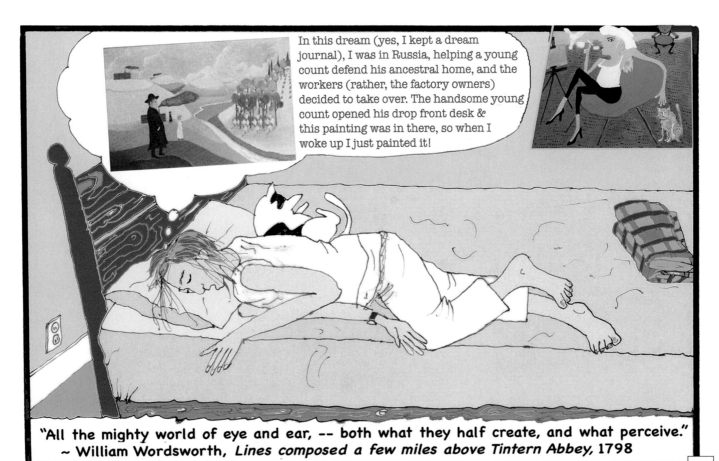

"All the mighty world of eye and ear, -- both what they half create, and what perceive."
~ William Wordsworth, *Lines composed a few miles above Tintern Abbey*, 1798

How many angels can dance on the head of a pin?

Rowena wants to know how many ideas can balance in the head of a person such as herself. How do you catch them? Are they more like flies or fleas? More like Cootie™ Build-a-Bug or Tiddley Winx™ ? She did a quick sketch to turn into a page. Herself trying to tame at least one idea, like a circus tiger. The theological question at top is from the Middle Ages. Thomas Aquinas (1225-1274 CE) was interested in this. He thought that no more than one angel could dance (stand? sit? draw? paint? sing? invent?) on the head of a pin at once. (Not because angels had bodies, but because they had causes.) btw Pin anatomy: A straight pin has three parts: head, shaft and point.

Rowena Sunder believes that there is no reason why more than one idea cannot exist in the same brain, because two ideas at the same time would be a new idea -- being the sum of two, three, four... etc. If angels are pure intelligence rather than corporeal bodies, a thousand of them could dance, whoop, holler, or lie down on the head of a pin. So, the question is: are ideas pure intelligence? What do you think?

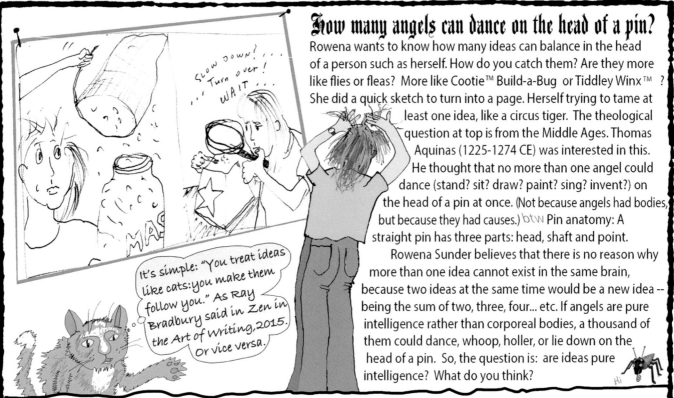

SLOW DOWN? . . . Turn over ! . . . WAIT . . .

MASON

It's simple: "You treat ideas like cats: you make them follow you." As Ray Bradbury said in Zen in the Art of Writing, 2015. Or vice versa.

Hi

"I wish I knew where [my ideas] come from; I'd move there." ~ Tom Stoppard, *Mel Gussow interview,* 1967
&"There is a right physical size for every idea." ~ Henry Moore, *Writings and Conversations,* 2002

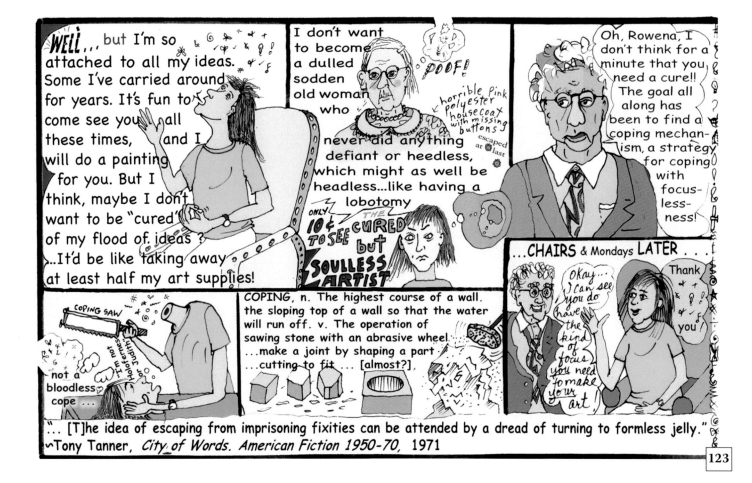

"... [T]he idea of escaping from imprisoning fixities can be attended by a dread of turning to formless jelly."
~Tony Tanner, *City of Words. American Fiction 1950-70,* 1971

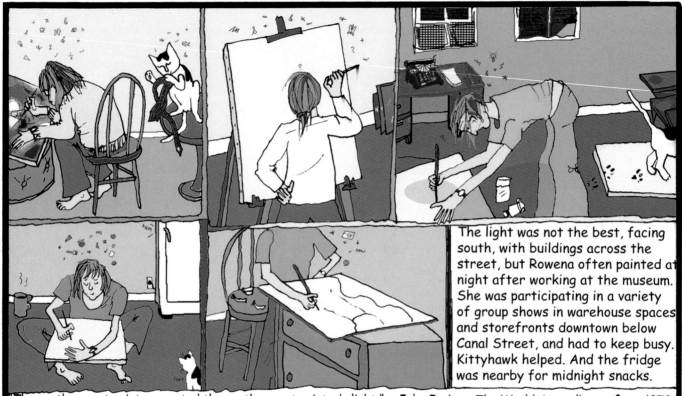

The light was not the best, facing south, with buildings across the street, but Rowena often painted at night after working at the museum. She was participating in a variety of group shows in warehouse spaces and storefronts downtown below Canal Street, and had to keep busy. Kittyhawk helped. And the fridge was nearby for midnight snacks.

"The south-garret painter coveted the north-garret painter's light." ~John Irving, *The World According to Garp*, 1978

& "Art is the apotheosis of solitude." ~ Samuel Beckett, *"Proust,"* 1931

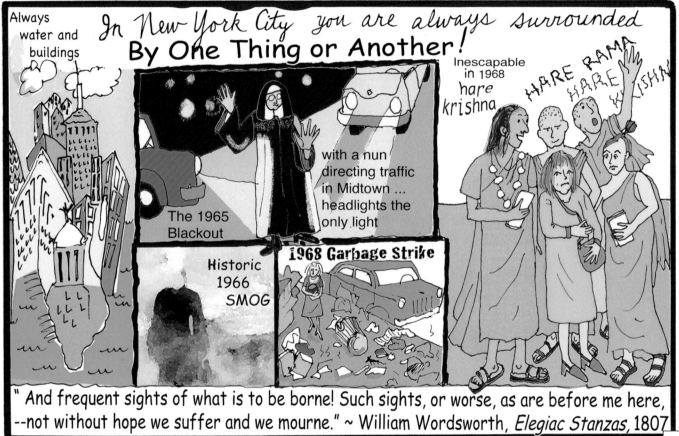

In New York City you are always surrounded *By One Thing or Another!*

Always water and buildings

The 1965 Blackout

with a nun directing traffic in Midtown ... headlights the only light

Historic 1966 SMOG

1968 Garbage Strike

Inescapable in 1968 *hare krishna*

HARE RAMA HARE KRISHNA

" And frequent sights of what is to be borne! Such sights, or worse, as are before me here, --not without hope we suffer and we mourne." ~ William Wordsworth, *Elegiac Stanzas*, 1807

125

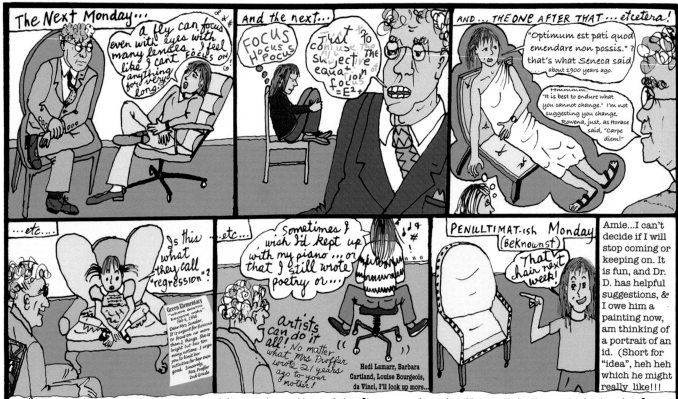

"Thoughts came to me so rapidly and continued to flow so abundantly…. I lost a whole host of of delicate details, because my pencil could not keep up…"~ André Breton, *Surrealist Manifesto 1*, 1924

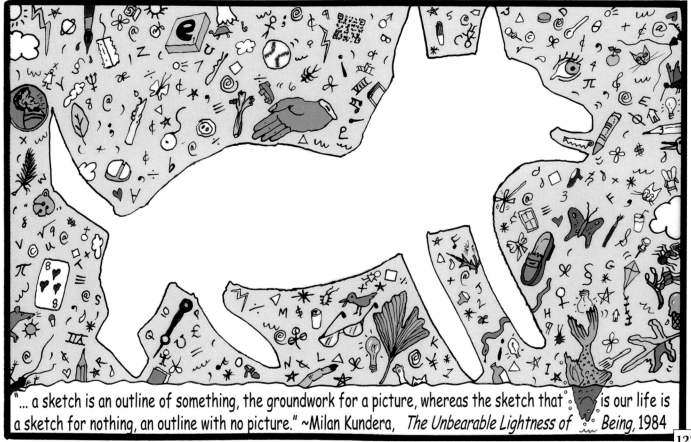

"... a sketch is an outline of something, the groundwork for a picture, whereas the sketch that is our life is a sketch for nothing, an outline with no picture." ~Milan Kundera, *The Unbearable Lightness of Being*, 1984

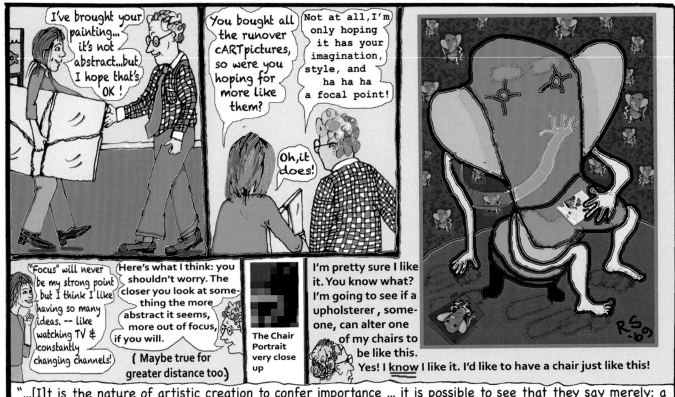

"...[I]t is the nature of artistic creation to confer importance ... it is possible to see that they say merely: a chair is a chair; and: no one can prevent the rain from falling down." ~ Berthold Brecht, *"Writing the Truth"* essay, 1935. tr by Richard Winston

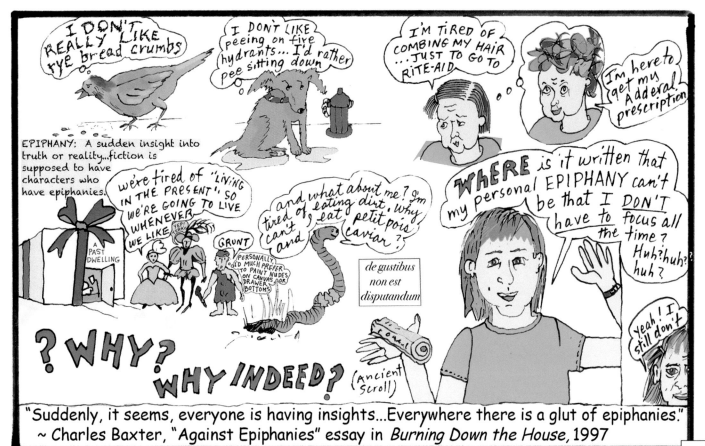

"Suddenly, it seems, everyone is having insights...Everywhere there is a glut of epiphanies."
~ Charles Baxter, "Against Epiphanies" essay in *Burning Down the House*, 1997

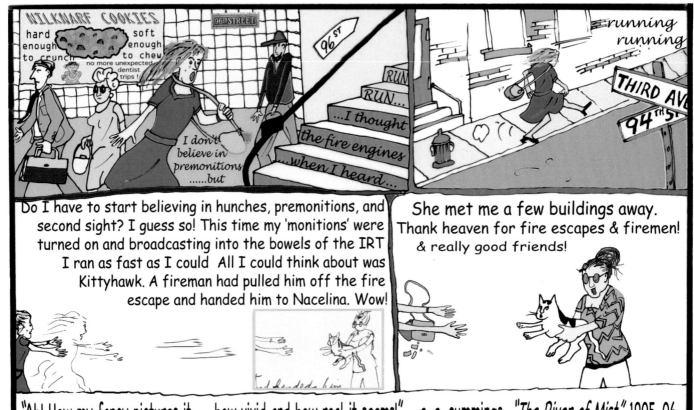

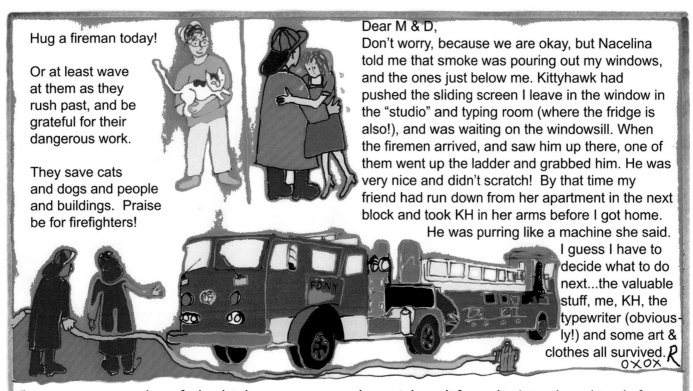

Hug a fireman today!

Or at least wave at them as they rush past, and be grateful for their dangerous work.

They save cats and dogs and people and buildings. Praise be for firefighters!

Dear M & D,

Don't worry, because we are okay, but Nacelina told me that smoke was pouring out my windows, and the ones just below me. Kittyhawk had pushed the sliding screen I leave in the window in the "studio" and typing room (where the fridge is also!), and was waiting on the windowsill. When the firemen arrived, and saw him up there, one of them went up the ladder and grabbed him. He was very nice and didn't scratch! By that time my friend had run down from her apartment in the next block and took KH in her arms before I got home.

He was purring like a machine she said.

I guess I have to decide what to do next...the valuable stuff, me, KH, the typewriter (obvious-ly!) and some art & clothes all survived. R
oxox

"Courage is worthy of the highest respect when risk to life or limb is dared in defence of others." ~ Herbert Spencer, *The Study of Sociology*, 1896

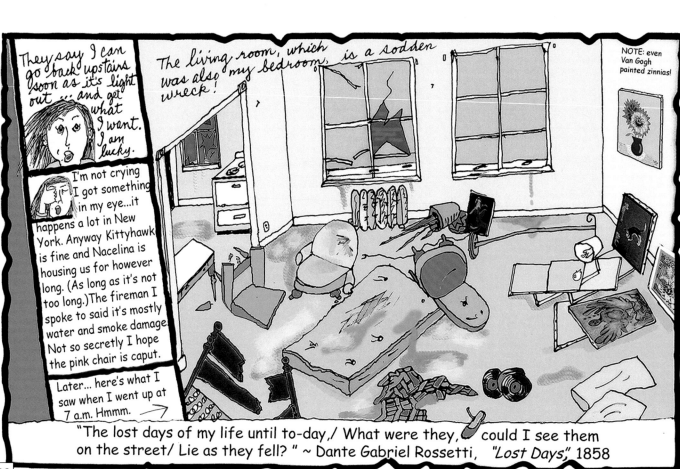

They say I can go back upstairs soon as it's light out... and get what I want. I am lucky.

I'm not crying I got something in my eye...it happens a lot in New York. Anyway Kittyhawk is fine and Nacelina is housing us for however long. (As long as it's not too long.) The fireman I spoke to said it's mostly water and smoke damage. Not so secretly I hope the pink chair is caput.

Later... here's what I saw when I went up at 7 a.m. Hmmm. →

The living room, which was also my bedroom, is a sodden wreck!

NOTE: even Van Gogh painted zinnias!

"The lost days of my life until to-day,/ What were they, could I see them on the street/ Lie as they fell?" ~ Dante Gabriel Rossetti, *Lost Days*, 1858

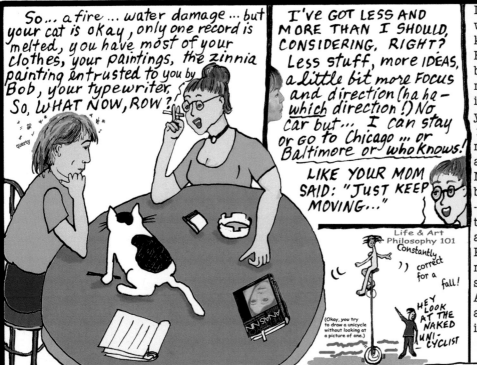

So... a fire ... water damage ... but your cat is okay, only one record is melted, you have most of your clothes, your paintings, the zinnia painting entrusted to you by Bob, your typewriter. So, WHAT NOW, ROW?!

query

I'VE GOT LESS AND MORE THAN I SHOULD, CONSIDERING, RIGHT? Less stuff, more IDEAS, a little bit more FOCUS and direction (ha ha — which direction!) No car but... I can stay or go to Chicago ... or Baltimore or who knows!

LIKE YOUR MOM SAID: "JUST KEEP MOVING..."

ANAIS

Life & Art Philosophy 101
Constantly
correct for a
fall!

(Okay, you try to draw a unicycle without looking at a picture of one.)

HEY LOOK AT THE NAKED UNI- CYCLIST

Dear M & D, I keep thinking about what you once said to me, Mom. "Just keep moving and nobody will notice!" Remember? It was about crooked hems, but I apply it to other situations, like mistakes. ~~And~~ But artists don't like being invisible, or at least not our art. I told you last week I can't decide what to do next. Still can't. My fun job really suits me, my neat friends & art connections, too. The apt will be fixed up quickly (I'm now at Nacelina's w/ my stuff & Kittyhawk) but I have to move pretty soon anyway -- Bob comes back early '71. So, I want to come stay w/ you for Think Time, _Thinksgiving,_ and then (prob.?) keep on moving. SO. Prepare for Invasion by your ever-messy offspring & her cat. I'll call you soon so we can figure out when exactly. Are you planning a vacation? I'll rent a car, unless you want to come get me in a truck! Hee hee.

Love, Rowena
xo (& Kittyhawk)

"Each friend represents a world in us, a world not born until they arrive, and it is only by this meeting that a new world is born." ~ Anaïs Nin, _DIARY,_ 1966

""...[S]ee her repacking into their proper places the many articles of the mind that have strayed during the day, ..." ~ J. M. Barrie, _Peter Pan_ [the play], 1937

Rowena could start rewriting her Art Manifesto, or she could pay more attention to the moment. It's a little late to train herself to focus on one thing at a time. Also, it's not what she believes is the way for her to go. "Phooie on that!" she's been heard to say. Every day is an opportunity to think of something new, trying it out, and hoping it will be as exciting as the thing she did the day before. The only thing she hasn't always done since writing that in 1965 is to make a note of the idea...just in case it turns out to be a good one. That's Rowena's advice for you all.

Now. Just yesterday she woke up with the idea that making a jigsaw puzzle self-portrait might just be the most apt self-portrait any artist could make. She thinks the one all taken apart is the best because it is *disassembled* in such a way that it doesn't *dissemble* her true self! Gosh! She was so pleased how that came into her mind! There will be more ideas every day.

Tomorrow and tomorrow won't creep in any petty pace for Rowena. She'll "keep on keepin' on" just like Curtis Mayfield sang to do.

"Before the beginning of great brilliance, there must be chaos." ~ *I Ching*, 4th Century BCE

"...[T]here are more and more endings ... faster and faster until this book is having 186,000 endings per second." ~ Richard Brautigan, *A Confederate General from Big Sur*, 1964

Being "tired of it all" is not a very good Rising Action, dramatic scene in novels. (Not to mention Climax, Falling Action and Denouement. (More later on Epiphany.) Fortunately I'm not tired of it all despite working on this for three years! I bet you thought the fire was the finale? It wasn't, but now you have the opportunity to imagine what next! Me too. I'm thinking. Is it time for ARTion Comix! Oh!... hmmmm. Uh. Hey! Hang on! I have an idea!

See you Later! R.

ROWEN: The name and what it means. I always thought it was the name of a tree... a magic tree, with fairies or witches, but that's spelled R O W A N. I found out (I'm sure my Mom and Dad didn't know) rowen has some interesting meanings especially for someone (like me) trying to figure out what to do next! For example, in one part of America it can mean the second cutting of hay! And in England it's another word for aftermath! Like, what's my "aftermath" ... what comes next after what came before! It dates back to Middle English... 1300 to 1500. That's when Chaucer and Shakespeare wrote. In fact, in *The Franklin's Tale*, in Chaucer's Canterbury Tales, he relates seeing a performance inside a castle hall where a barge was "maad come in a water ... rowen up and doun... ." Men were underneath making the barge move as if on water. Sounds like a play for Robert Wilson! (Who, like Dr. Desmoines and Rowena, has a thing for chairs!) Sir Walter Scott's book IVANHOE (1819) has a character named Rowena -- a timid blond.

The problem of the modern novel is what will a madman do with a dull world. In the fairy tales the cosmos goes mad; but the hero does not... . In modern novels the hero is made before the book begins. . . ."
~G. K. Chesterton, *Tremendous Trifles*, 1909

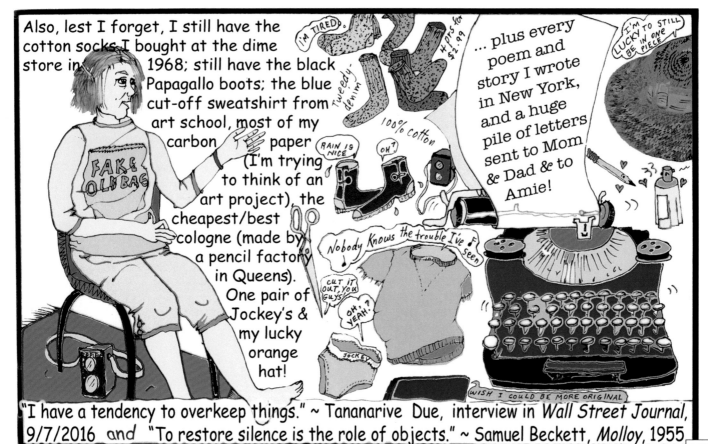

Also, lest I forget, I still have the cotton socks I bought at the dime store in 1968; still have the black Papagallo boots; the blue cut-off sweatshirt from art school, most of my carbon paper (I'm trying to think of an art project), the cheapest/best cologne (made by a pencil factory in Queens). One pair of Jockey's & my lucky orange hat!

FAKE OLD BAG

I'M TIRED.

4 prs. for $2.99

Tweedy-denim

100% cotton

... plus every poem and story I wrote in New York, and a huge pile of letters sent to Mom & Dad & to Amie!

I'M LUCKY TO STILL BE IN ONE PIECE

RAIN IS NICE

OH!

Nobody Knows the trouble I've seen

CUT IT OUT, YOU GUYS

OH, YEAH?

JOCKEY

WISH I COULD BE MORE ORIGINAL

"I have a tendency to overkeep things." ~ Tananarive Due, interview in *Wall Street Journal*, 9/7/2016 and "To restore silence is the role of objects." ~ Samuel Beckett, *Molloy*, 1955

The Scattering of Waves off Objects

I used to draw in dirt. Chairs and houses, paths, dogs, cats, alligators. I scuffed or blew them away. Then I drew with crayons, smearing one impulse into another. Imagined self. Yellowround sun played tag with whitefluff clouds. They exist in sky, and I proved that with a Celestial Blue crayon. Next I tried watercolors. Gray brush jar water was evidence of what I never was or might be: a watercolororist – too much water, too much urgency.

My ideas don't flow, they jump at me out of corners, out of accumulations, shadows, creases, echoes, scabs, scars, fingerprints, footprints, scuffs, wrinkles, holes, dust, scratches, pulled threads and dropped stitches. Mirrors.

I have proof that I was/am there/here. I left my shy shell. I leapt from Toledo to escape formula or destiny. Art was not enough, I wanted to catch and release dreams as well as shadows. My bed as a duck blind. Writing is proof of thought, words and ink. Paintings are proof of ideas and paint and a surface. I am proof that focus can bounce

and

turn around.

"I've been known to reach the bed/ ideas still famished in my head." ~ Roman Payne, *Cities and Countries,* 2007
"They fly into one's head like birds." ~ John Cage, *Silence: Lectures and Writings*, 1961

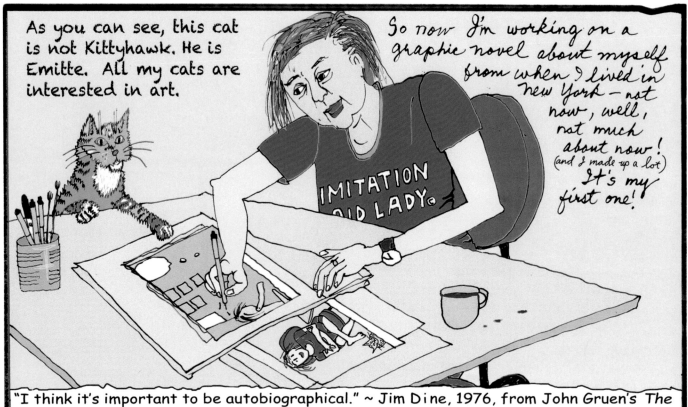

As you can see, this cat is not Kittyhawk. He is Emitte. All my cats are interested in art.

So now I'm working on a graphic novel about myself from when I lived in New York — not now, well, not much about now! (and I made up a lot) It's my first one!

"I think it's important to be autobiographical." ~ Jim Dine, 1976, from John Gruen's *The Artist Observed*, 1991 and/or "Only then can I feel his fuzzy neck and chin." ~ Jim Carroll, *Forced Entries, The Downtown Diaries: 1971-1973*, 1987

139

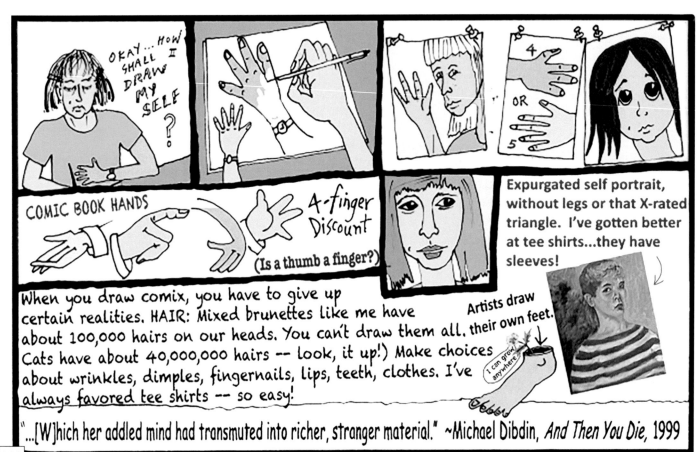

OKAY...HOW SHALL I DRAW MY SELF?

COMIC BOOK HANDS

A-finger Discount

(Is a thumb a finger?)

4 OR 5

Expurgated self portrait, without legs or that X-rated triangle. I've gotten better at tee shirts...they have sleeves!

Artists draw their own feet.

I can grow anywhere

When you draw comix, you have to give up certain realities. HAIR: Mixed brunettes like me have about 100,000 hairs on our heads. You can't draw them all. Cats have about 40,000,000 hairs -- look, it up!) Make choices about wrinkles, dimples, fingernails, lips, teeth, clothes. I've always favored tee shirts -- so easy!

"...[W]hich her addled mind had transmuted into richer, stranger material." ~Michael Dibdin, *And Then You Die*, 1999

140

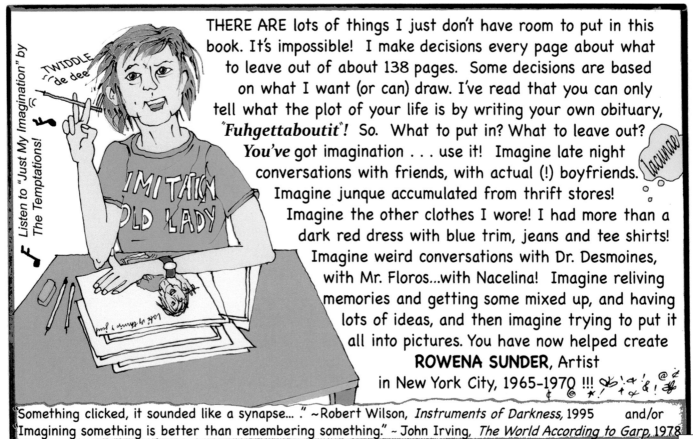

THERE ARE lots of things I just don't have room to put in this book. It's impossible! I make decisions every page about what to leave out of about 138 pages. Some decisions are based on what I want (or can) draw. I've read that you can only tell what the plot of your life is by writing your own obituary, *"Fuhgettaboutit"!* So. What to put in? What to leave out? *You've* got imagination . . . use it! Imagine late night conversations with friends, with actual (!) boyfriends. Imagine junque accumulated from thrift stores! Imagine the other clothes I wore! I had more than a dark red dress with blue trim, jeans and tee shirts! Imagine weird conversations with Dr. Desmoines, with Mr. Floros...with Nacelina! Imagine reliving memories and getting some mixed up, and having lots of ideas, and then imagine trying to put it all into pictures. You have now helped create **ROWENA SUNDER**, Artist in New York City, 1965-1970 !!!

"Something clicked, it sounded like a synapse... ." ~Robert Wilson, *Instruments of Darkness*, 1995 and/or "Imagining something is better than remembering something." ~ John Irving, *The World According to Garp*, 1978

HOW TO PREPARE FOR DOING A GRAPHIC NOVEL

- Save visuals, especially in your memory.
- Don't be afraid to draw things from memory -- such as bikes, fire hydrants, chairs, even animals!
- Don't be afraid of making mistakes! Use them!
- Break any rules you want to!
- Really work on faces & belongings/clothes of characters. Color with ink, watercolor, pencils, Photoshop or Adobe Illustrator. This book was done with handdrawn pages, scanned, then colored with Photoshop.
- Take reference photos & keep pix from mags & newspapers
- Make lists of backgrounds & objects which tell a story.
- Read *Breakdowns* and *Maus* by Art Spiegelman
- Read *Can't We Talk about Something More Pleasant*? by Roz Chast (& anything by her!)
- Read anything by Lynda Barry. You won't be sorry!
- Read anything by R. Crumb (or Aline Kominsky-Crumb, for that matter)
- Read any books on graphic novels you want!
- Read any graphic novels that appeal to you.
- Look at the wordless woodcut novels by Lynd Ward from the 1930s and see how much emotion and action can be done without text!
- Don't overdo text...that's what pictures are for!
- Jot down ideas wherever you are! (Walk your dogs...a lot!)

Personally, I like to put some repeating motifs in — or, RATHER, I discovered there are motifs that are like bit players ...

...see how many you find !

"To subdue one's self to one's own ends might be dangerous." ~ Dorothy Sayers, *Gaudy Night*, 1935 &

" 'A ha! Yes, I know what it is, it's myself.' " ~ Joseph Campbell, in interview with Tom Collins, 1985? in *The New Story (IC#12)* Originally published in Winter 1985/86

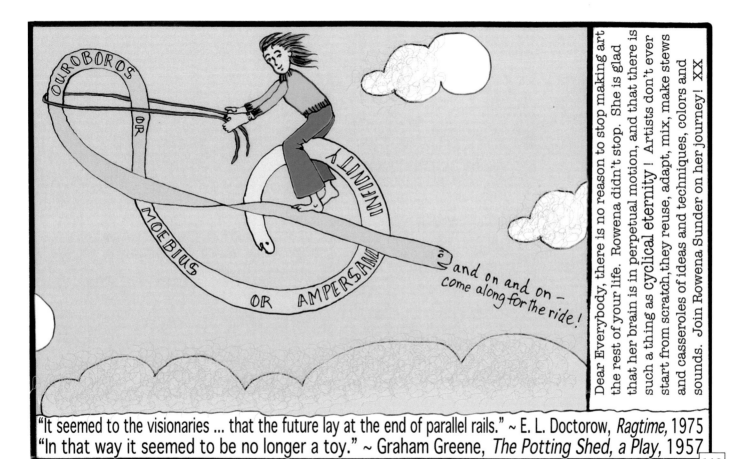

Dear Everybody, there is no reason to stop making art the rest of your life. Rowena didn't stop. She is glad that her brain is in perpetual motion, and that there is such a thing as cyclical eternity! Artists don't ever start from scratch, they reuse, adapt, mix, make stews and casseroles of ideas and techniques, colors and sounds. Join Rowena Sunder on her journey! XX

"It seemed to the visionaries ... that the future lay at the end of parallel rails." ~ E. L. Doctorow, *Ragtime*, 1975
"In that way it seemed to be no longer a toy." ~ Graham Greene, *The Potting Shed, a Play*, 1957

IF YOU WANT TO GET IN THE MOOD, LISTEN TO THE MUSIC

WHAT ROWENA SAW-HEARD-READ-WATCHED-LISTENED TO-WORE-ATE-BOUGHT-FOUND

The Collector by **John Fowles**

ARGOSY BOOKSTORE

JONI MITCHELL

Lexington Ave IRT Subway

bellbottoms
The Talking Heads
Orange Julius **etc**

The Automat sandals

Motown

hot pants **etc** & Pearl Street Diner

etc

↣ On the Beach by Nevil Chute

Stevie Wonder

Michael Jackson

Lloyd Price's "Stagger Lee" ↘crosstown buses

& The Beatles' "Eleanor Rigby" **etc** ↯ all by The Platters

TINA TURNER

CARWASH Fats Domino Dr. Scholl's

Village Voice

Tad's Steak House (steak, baked potato, salad: $1.49) "The Red Desert" Michelangelo Antonioni

Dandelion Wine by Ray Bradbury Bela Bartok's "Mikrokosmos" **etc** ...PINK FLOYD ↣WOLMAN

Rufus Thomas' "Walkin' the Dog" "STAX "Metropolis" Fritz Lang Petula Clark's "Downtown" RINK" WABC-AM (770)

Babatunde Olatunji "Drums of Passion" short skirts Chumley's New York Times "La Dolce Vita" Federico Fellini Joe Tex

Invisible Man by Ralph Ellison & LONG skirts "Another Brick in the Wall"

THE GAP BAND P.J. Clarke's **etc** The Tin Drum by Gunter Grass Stravinsky's "Rite of Spring" going to New Jersey

blue jeans pasta ad innnitum The Supremes' "Stop in the Name of Love" JAMES BROWN Cat's Cradle by Kurt Vonnegut

LAKESIDE
OHIO PLAYERS Pete's Tavern On the Road by Jack Kerouac & "La Strada" Federico Fellini **etc** flipflops

George Clinton

"Woman in the Dunes" Hiroshi Teshigahara Little Eva's "The Locomotion" Wo Hop at 17 Mott in Chinatown

LITTLE EVA's THE LOCOMOTION KURTIS BLOW PRINCE WINS (1010 kHz) "10-10 Wins"

Chubby Checker's "The Twist" ☺ going to Queens or Brooklyn **etc** bananas

Fear of Flying by Erica Jong

The STRAND John Coltrane The Lord of the Rings by J.R.R. Tolkein boots Cedar Tavern TURTLE ISLAND

Maxs Kansas City

Staten Island Ferry ∿∿ **etc** $ Aretha Franklin's "Respect" the Elevated ∫ rayon shirts big collars

Stan Getz **etc** LIL BOW WOW bagels mit schmeer WNEW-FM (102.7 FM) The Doors' "Light My Fire" FUNK

Del Shannon's "Runaway" "Last Year at Marienbad" Alain Resnais "Hard Day's Night" The Beatles Pizza by the slice

FILLMORE EAST ♯ slingbacks

The Spy Who Came in from the Cold by John le Carre **etc** Marvin Gaye's "I Heard It Through the Grapevine"

THE COMMODORES Horace Silver The COASTERS

thrift stores galore The Everley Brothers' "Cathy's Clown" The Book of Imaginary Beings by Jorge Luis Borges

ALOE BLACK THE LOUNGE LIZARDS

Born Free: A Lioness of Two Worlds by Joy Adamson & Empire Diner↲ wild colorful prints Papaya King **etc**

"...[T]he most vivid figments among which we live." ~ Daniel J. Boorstin, *The Image. A Guide to Pseudo-Events in America*, 1962 &

"...[I]ncreasingly difficult to distinguish between Art and Life."~Julian Barnes, *Flaubert's Parrot*, 1984

144

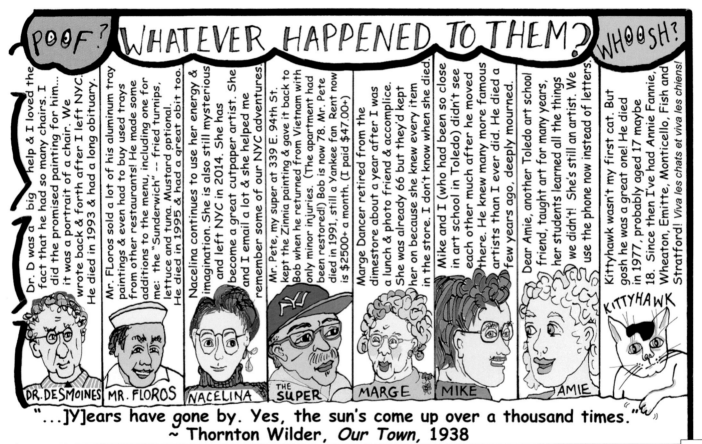

POOF? WHATEVER HAPPENED TO THEM? WHOOSH?

DR. DESMOINES: Dr. D was a big help & I loved the fact that he had so many chairs. I did the promised painting for him... it was a portrait of a chair. We wrote back & forth after I left NYC. He died in 1993 & had a long obituary.

MR. FLOROS: Mr. FLoros sold a lot of his aluminum tray paintings & even had to buy used trays from other restaurants! He made some additions to the menu, including one for me: the "Sunderwich" -- fried turnips, lettuce and tuna. Mustard optional. He died in 1995 & had a great obit too.

NACELINA: Nacelina continues to use her energy & imagination. She is also still mysterious and left NYC in 2014. She has become a great cutpaper artist. She and I email a lot & she helped me remember some of our NYC adventures.

THE SUPER: Mr. Pete, my super at 339 E. 94th St. kept the Zinnia painting & gave it back to Bob when he returned from Vietnam with only minor injuries. (The apartment had been restored!) Bob is now 78. Mr. Pete died in 1991, still a Yankee fan. Rent now is $2500+ a month. (I paid $47.00+)

MARGE: Marge Dancer retired from the dimestore about a year after I was a lunch & photo friend & accomplice. She was already 66 but they'd kept her on because she knew every item in the store. I don't know when she died.

MIKE: Mike and I (who had been so close in art school in Toledo) didn't see each other much after he moved there. He knew many more famous artists than I ever did. He died a few years ago, deeply mourned.

AMIE: Dear Amie, another Toledo art school friend, taught art for many years, her students learned all the things we didn't! She's still an artist. We use the phone now instead of letters.

KITTYHAWK: Kittyhawk wasn't my first cat. But gosh he was a great one! He died in 1977, probably aged 17 maybe 18. Since then I've had Annie Fannie, Wheaton, Emitte, Monticello, Fish and Stratford! *Viva les chats et viva les chiens!*

"...[Y]ears have gone by. Yes, the sun's come up over a thousand times."
~ Thornton Wilder, *Our Town*, 1938

Directory of Artists Exhibiting in the Galleries

Rowena art piece numbers with artist name. See next page Artist Name List for titles

1 Manley. **2** Sajecki. **3** J. Young. **4** Lewenz. **5** R.D. Franklin. **6** McFarland. **7** Sunder. **8** MM Franklin. **9** Zubin. **10** Bucknell. **11, 12, 13** Sunder. **14** Samet. **15** Storms. **16** Antreasian. **17** Anklam. **18** Van Allen. **19** Alexander. **20** U. Populoh. **21** Ditter. **22** Hadley. **23** Sunder. **24** Mayhew. **25** Sunder. **26** Unknown. **27** Kopelke. **28** Sunder. **29** McCall. **30** R.M. Franklin. **31** MM Franklin. **32** Schweitzer. **33** Van Allen. **34** Anchor. **35** Sunder. **36** L. Franklin. **37** C. Franklin. **38** Sunder. **39** Spence. **40** Retzler. **41** Matanle. **42** Schwing. **43** Hoagg. **44** Fletcher. **45** Spence. **46** N. Franklin. **47** Schwing. **48** Sunder. **49** Bell. **50** Redmond. **51** A.N. Hartman. **52** V. Populoh. **53** Farnham. **54** Bennett. **55** Parks. **56** Bell. **57** Hogarth. **58** L. Franklin. **59** Siron. **60** Persoff. **61** Fahey. **62** Taylor. **63** L. Franklin. **64** Floyd. **65** Downing. **66** Boyd. **67** Muirhead. **68** Dinoto. **69** K. Sunder. **70** MM Franklin. **71** Redmond. **72** G. Young. **73** R.D. Franklin. **74** Ackerman. **75** Fenton. **76** Clark. **77** Gross. **78** C. Moscatt. **79** Goecke. **80** Field. **81** Sunder. **82** Wondolowski. **83** Ronalds. **84** Sunder. **85, 86** Linden. **87** Fair. **88** Sunder. **89** R.M. Franklin. **90** Abr. Hartman. **91** R.M. Franklin. **92** P. Moscatt. **93** Downing. **94** R.D. Franklin. **95** Sunder. **96** L. Franklin. **97** Persoff. **98** Vandenberg. **99** Johnson. **100** Leonard. **101** Konsolas. **102** Roberts. **103** E. Hartman. **104** Hogarth. **105** Sunder. **106** Barber. **107** Sunder.

Artist Name List with Titles and Art Piece Numbers

Note that while proportions of each piece are consistent to the original, its size in relation to other works is not. Something quite small may be big and vice versa.